IMAGES
of America

IPSWICH REVISITED

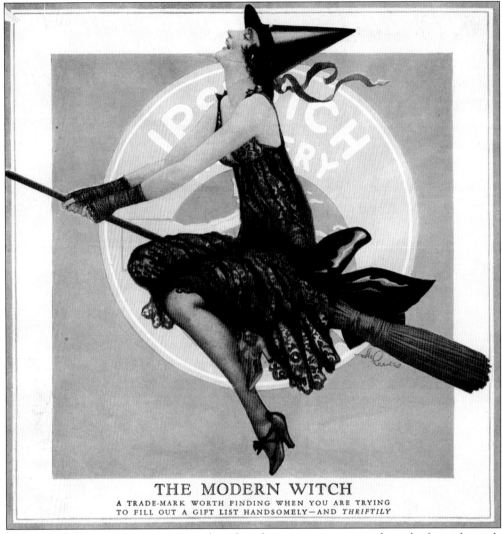

THE MODERN WITCH

A TRADE-MARK WORTH FINDING WHEN YOU ARE TRYING
TO FILL OUT A GIFT LIST HANDSOMELY—AND *THRIFTILY*

The Ipswich Hosiery Company's initial media advertising concentrated on the Ipswich witch theme, with most of the witches illustrated being extremely ugly. By the time it understood that a product meant for women should have attractive models with attractive legs, its product did not match the new image. Without the money to retool its knitting machinery, the company was forced out of business in 1928. (Courtesy of Martha Varrell.)

On the cover: Please see page 95. (Courtesy of the Barton Collection, Ipswich Historical Society.)

IMAGES
of America

IPSWICH REVISITED

William M. Varrell
for the Ipswich Historical Society

ARCADIA
PUBLISHING

Published by Arcadia Publishing
Charleston SC, Chicago IL, Portsmouth NH, San Francisco CA

Printed in the United States of America

Library of Congress Catalog Card Number: 2006921283

For all general information contact Arcadia Publishing at:
Telephone 843-853-2070
Fax 843-853-0044
E-mail sales@arcadiapublishing.com
For customer service and orders:
Toll-Free 1-888-313-2665

Visit us on the Internet at http://www.arcadiapublishing.com

CONTENTS

ACKNOWLEDGMENTS

With the completion of this second book in the Images of America series, we wish to thank Ipswich Historical Society (IHS) director Bonnie Hurd Smith for her interest, support, and professional expertise; the society's president, Pat Tyler, for her constant stewardship of our photography archive, her editing skills, and her point of view as a born and bred Ipswich resident; and the society's administrative assistant, Diane Young, for helping to prepare the manuscript. We are also very grateful to Paul and Cathleen McGinley for their extensive review and editing of the book.

We are especially indebted to our town's many professional photographers of the past, particularly stereopticon photographer George H. Jones, who died in 1880 at age 49, as well as George Dexter and Edward Darling, who were active at the end of the Victorian era.

Great appreciation must go to Howard Fosdick for the detailed, electronic obituary index he has created for the Ipswich Public Library. Without it, the text research would have been a shadow of what it became.

As for the photographs, we are extremely grateful to the family of William Barton, who had donated his fabulous collection of Edward Darling photographs with detailed captions to the permanent collection of the Ipswich Historical Society. We are also indebted to David Thayer for the loan of many photographs of his ancestors, the Appletons, and to Bill George for the freedom to use whatever we wished from his extensive and important collection.

We also especially want to thank Victor Dyer, Paula Grillo, and Genevieve Picard of the Ipswich Public Library for their support and for the use of their photographic collection; Stephanie R. Gaskins, curator of the Arthur Wesley Dow collection at the Ipswich Historical Society; and Kate Day of the Ipswich Department of Planning and Development for her sincere interest and support.

There are many individuals who loaned us their family treasures. The constant flow of exceptional new images made every day seem like Christmas. Among them are Jane and Ben Collins, Wayne Castongay, Bessie McKay, Alicia Hills Moore, Donna Bowen, Maureen Bucklin and Patricia Whalen, Karen Donovan, Jeanne and Jim Engel, Phil Grenier, Billy Grant, Mildred Hulbert, Crocker Snow Jr., Ipswich town clerk's office, Lee Nelson, Rev. Merle Pimental, Wilbur Trask, John Moss, Bill Wasserman, and also my wife, Martha Varrell, for the use of pictures, for providing transportation, and for polishing the rough edges of my original draft.

Finally, we thank Richard Slavin for his photographic expertise in printing many old negatives that became more than just dark shadows in the society's collection. Unless otherwise noted, all photographs are from the Ipswich Historical Society.

Although this second Ipswich book is now complete, we look forward to the gift and loan of other examples of Ipswich photographic history that we have not yet had the opportunity to enjoy.

INTRODUCTION

The invention of photography roughly 150 years ago was a marvel. All of a sudden, people could quickly capture moments in time. What might take an artist weeks to paint, or a poet days to describe, photographers could document in a flash.

Bill Varrell's second volume of photographs, *Ipswich Revisited*, is a treasure trove of glimpses into Ipswich's rich past, culled from public and private collections. Many of these photographs are published here for the first time. As Bill explained to me, "Once these pictures have been discovered, I can't bear the thought of them sitting in the dark. They need to be seen."

The photographs he has chosen are an engaging pictorial journey back in time. They call to Ipswich residents to rediscover their town, and to visitors to imagine—with book in hand—what downtown was like before cars, when trolleys ran, or when fire pumps were drawn by horses. What did the Ipswich painters see when they climbed Town Hill to sketch? What were parades and celebrations like when Teddy Roosevelt came to town, when veterans marched, and town anniversaries were observed?

With Bill's book, you can stand in the midst of a present-day Ipswich streetscape and picture the hotels, grand homes, and modest shops that were lost to fire. You can see where Bernie Spencer and his team of horses plowed the sidewalks, where the "Linehan sisters" ran their popular teahouse, where mill workers lived and made hosiery, and where ships unloaded coal and lumber at Town Wharf to be sent downriver.

You can also see Ipswichers at play in the old days—enjoying family picnics, outings to the beach, boating, or dressing up in colonial garb for Olde Ipswich Days. Because as much as this book documents change, it also presents a reassuring continuity.

Ipswichers still flock to Crane Beach, still indulge at the Clam Box, still care for Ipswich's numerous First Period houses and vast open spaces. Appleton Farms is still in operation, the train comes and goes to Boston, and downtown shops thrive. This close-knit community, forged out of colonists, farmers, fishermen, tradespeople, mill workers, and business owners, continues along.

In 1896, at the unveiling of the South Village Green Memorial Tablets, the renowned Ipswich historian and founder of the Ipswich Historical Society, Thomas Franklin Waters, declared, "the Past still lingers in memory and the glory of the earliest days is not eclipsed by the happenings of the present . . . [with the dedication of this memorial], we hope to foster historic spirit and awaken local pride."

More recently, the author David McCullough said, "I love to go to the places where things happen. I like to walk the walk and see how the light falls and what winter feels like. . . . To me

history ought to be a source of pleasure. It isn't just part of our civic responsibility. To me it's an enlargement of the experience of being alive, just the way literature or art or music is."

Let Bill Varrell's book awaken your historic spirit and local pride. Rediscover Ipswich, or discover it for the first time. See the places. Walk the walk. Find out more. And enjoy!

Bonnie Hurd Smith
Executive Director
Ipswich Historical Society and Museums
March 2006

One

THE IPSWICH RIVER, HISTORIC WORKHORSE

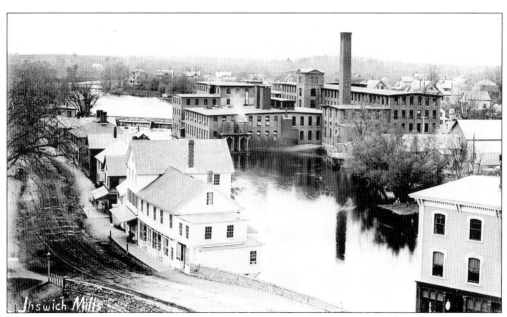

This is the Ipswich River at its most powerful, from the Choate Bridge (the oldest stone arch bridge in North America), to the dam and falls, and on to the Ipswich Hosiery Mill, which since 1868 has been the backbone of local manufacturing. One might think the river has not changed in 100 years, but a close inspection reveals many subtle differences through the local march of time.

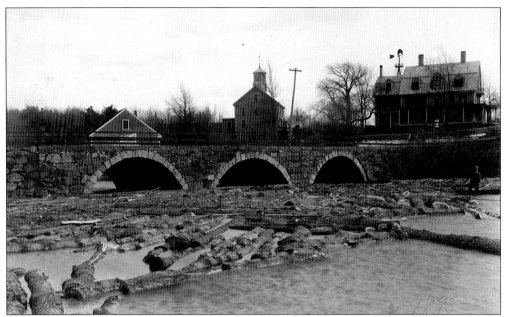

This busy industrial scene at Norwood's Bridge on Mill Road (built in 1832) shows the significance of waterpower to move logs to and through Norwood's Mill on the Ipswich River. Although the mill is on the Hamilton side of the river that divides the towns of Ipswich and Hamilton, it employed Ipswich men and clearly illustrates the importance of waterpower to the local economy. (Courtesy of the Barton Collection, IHS.)

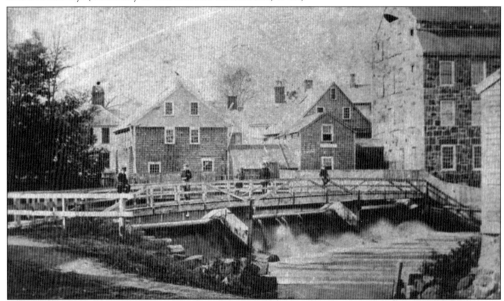

In 1828, Augustine and George Washington Heard formed the Ipswich Manufacturing Company and built this stone textile mill at the site of the current South Main Street Dam. Later known as the Dane Manufacturing Company, it was just after the Civil War when Amos H. Lawrence, of Merrimac River fame, bought out the local company and founded the Ipswich Hosiery Mill. As shown here, the earliest mills also had a footbridge across the river, similar to the new bridge scheduled to open in 2006.

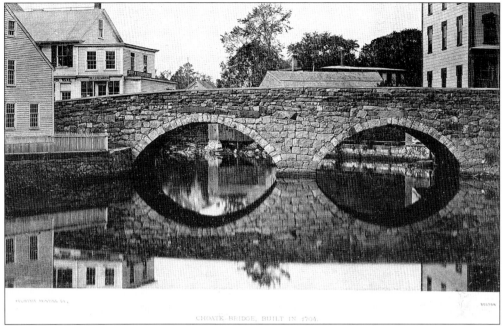

CHOATE BRIDGE, BUILT IN 1764.

This picture that was taken before 1900 shows the Choate Bridge that spans the Ipswich River in downtown Ipswich. Built in 1764 to facilitate pioneer stagecoach service between Boston and Portsmouth, New Hampshire, it is the oldest stone arch bridge in use in North America. With minor exceptions, the same picture could be taken today.

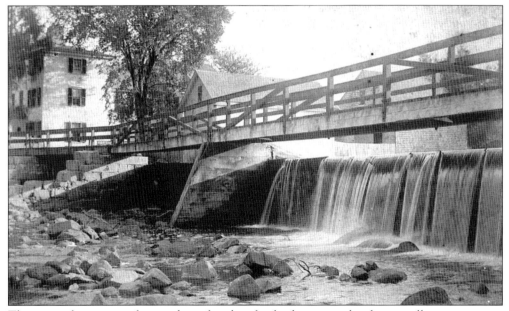

This view shows one of a number of earlier footbridges over the dam to allow easy access between South Main Street boardinghouses and the Ipswich Hosiery Mill. In the background is the still-standing Edward Dutch house, built in 1723, on South Main Street.

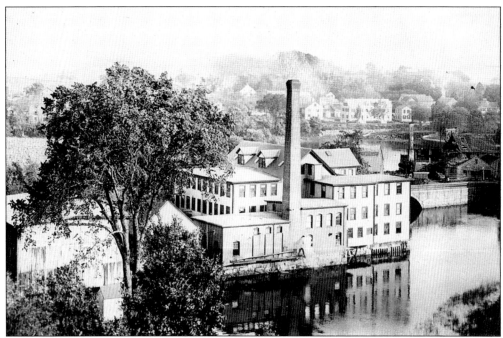

This view of the County Street mill area could have been taken from George Dexter's photography studio on the third floor of the former Ipswich Female Seminary building. The recent ruins of Canney's Box Mill are seen from the right. Originally built by James Damon, it was said to be a firetrap and had a number of fires prior to its destruction in December 1895. The Ipswich Woolen Mill that closed in November 1886 is in the foreground.

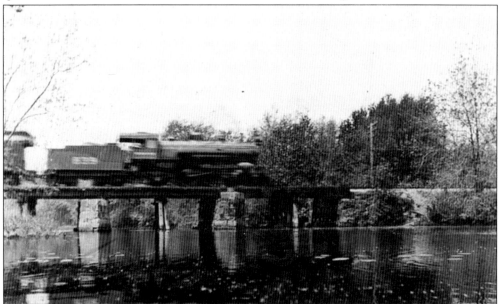

This is an early railroad bridge over the Ipswich River, about a quarter of a mile south of the current station. Prior to its initial construction, water-driven mills and river-born transportation were so important that one local faction delayed construction of a new bridge while they lobbied to make it a drawbridge.

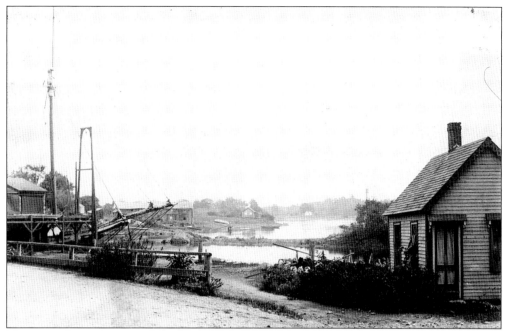

This view shows the area of the current Town Wharf when it was still used as a dock for coal schooners owned by William Brown and others. From 1874 until 1910, this coal wharf was operated by former mariner John S. Glover. On the far shore, in the center of the picture, is Edward Choate's shipyard, where many tall ships and the local pleasure steamboat *Carlotta* were constructed.

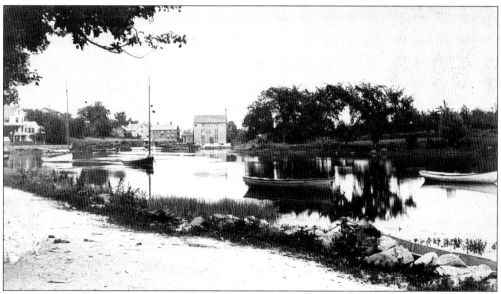

This rather placid picture of the Ipswich River from Water Street near the Green Street Bridge could almost be taken today with the exception of the tall building in the center background. Fortunately, there is documentation that the tall building, currently part of Tedford's Lumber Yard in Brown Square, originally sat on Choate's Wharf and was moved across town to Brown Square where it became Chaplin's grain storage.

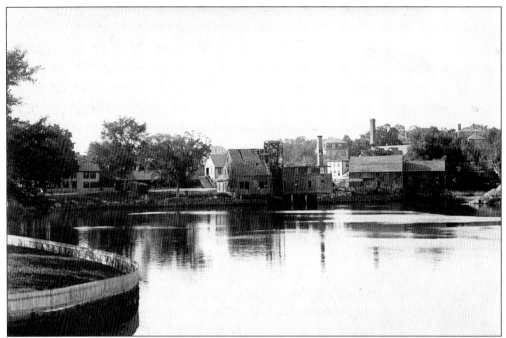

This picture was taken from the cove looking toward County Street and the businesses at Falls Island. It was taken in January 1896, shortly after the fire that destroyed the roof of Canney's Box Factory. On the left of the fire ruins is the space now known as Sawmill Point, preserved and restored as a park in 2005 with a generous gift from the late Alice Shurcliff.

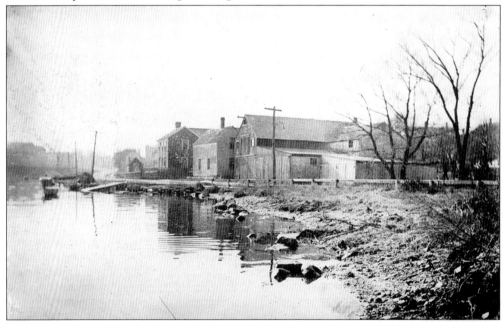

Here the edge of the river can be seen from near the bottom of Hovey Street looking back toward the site of the Green Street Bridge. The large building in the foreground is Edward Dodge's boathouse that burned in June 1943. The still-standing Glazier-Sweet house is shown just behind the boathouse.

These logs are piled up beside the County Street Mill, built by James Damon on Falls Island. The natural sluiceway at that point, and the mills that resulted, gave Sawmill Point its name.

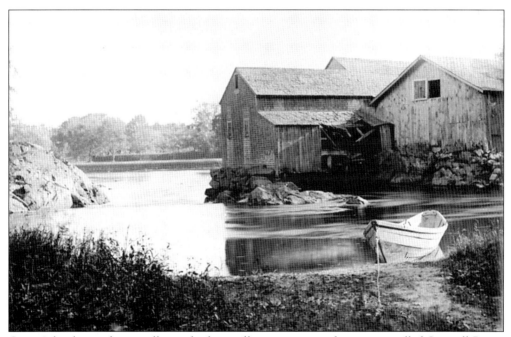

Carter's lumber and gristmill was the last mill remaining at what is now called Sawmill Point. Standing on the County Street Bridge and looking across what were historically called "the lower falls," one can still see a small portion of the stone pier that supported the midriver end of that building.

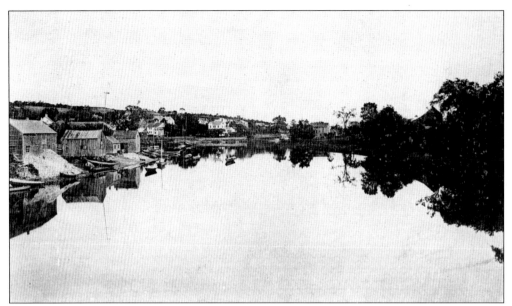

According to a description written by William J. Barton in 1963, this view taken in 1894, from the Green Street Bridge looking downriver, shows the clam shacks of J. Dennison Rust, Charles Rust, and J. Lewis Grant, all of the firm of Rust and Grant, fish dealers. Next is the house of Ephraim Grant, torn down around 1960, and next to that a house used to store sand for plastering houses. Finally there is the home of the "Stanwood sisters," who ran a private school. (Courtesy of the Darling Collection, IHS.)

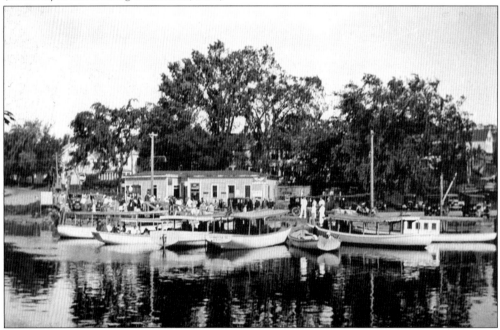

Many small naptha launches await passengers downriver. The 25¢ fare was the best transportation to the beach and cottages on the Little Neck and Great Neck before automobiles. This picture was taken before 1923, when the Claxton family leased the town-owned building in the background and converted it into a summer seafood restaurant.

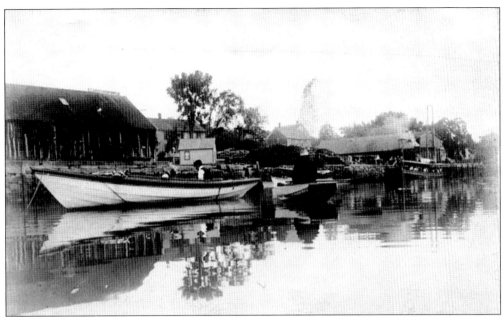

At this part of the river, along Water Street with Glover's Wharf on the left and Brown's Wharf on the right, is the excursion steamboat the *Carlotta* is loading for a trip downriver, and the tall ships are unloading their cargoes of lumber and coal. Glover's business was started by John S. Glover in 1874, sold to Charles L. Lovell in 1910, and that business was sold to Elliot Brothers in 1942.

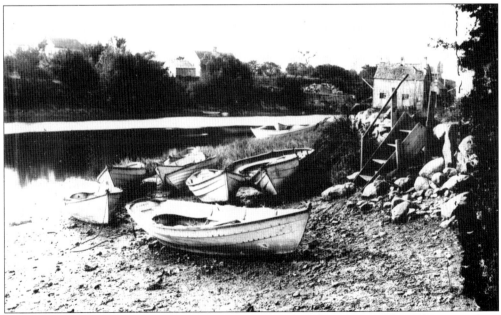

For many years, the Ipswich River has been used for work and recreation. This 1894 view is from the current location of the Ipswich Outboard Club's launching ramp on Water Street looking upriver. When not needed by their fishermen owners, these boats could be rented for a leisurely afternoon on the river. The houses in the background are on Turkey Shore Road. Note the second Green Street Bridge being constructed in 1894.

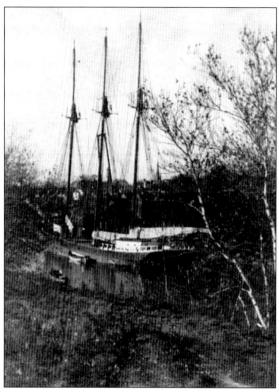

This tall ship is tied up at Brown's Wharf. Because the river sometimes froze during the winter, most coal shipments were delivered by rail. But as soon as weather permitted, as late as the 1890s, coal was delivered to the wharf in locally owned ships. Those same ships also spent the winter stripped and tied up at the local docks.

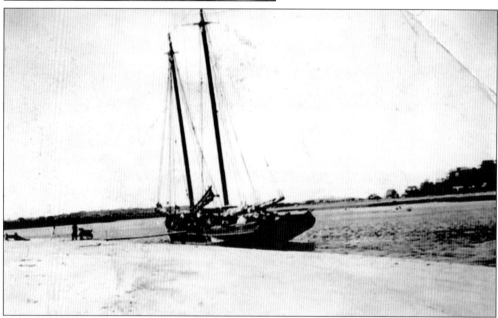

This 1920s picture of a sand schooner at Steep Hill Beach, with Little Neck on the right, is definitely not the *Ada K. Damon*, which sank here in 1909. But it could be the local sander *Edward D. Eveleth*, which was also wrecked on Crane Beach. In 1907, the captain of the *Eveleth* was reported to have committed suicide but was later found in the Ipswich jail working off a "bender." (Courtesy of the Varrell Collection.)

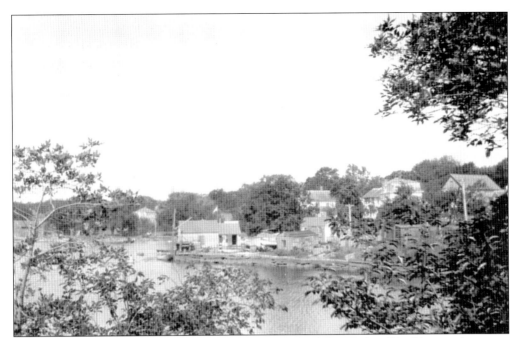

This scene was taken from just above the Town Wharf and shows a small building in the center that was used by Jenning's Seafood Company, now the site of Melanson's Boat House. John Glover's coal sheds are in the shadows on the right, and the steeple of the First Church can be seen in the distance.

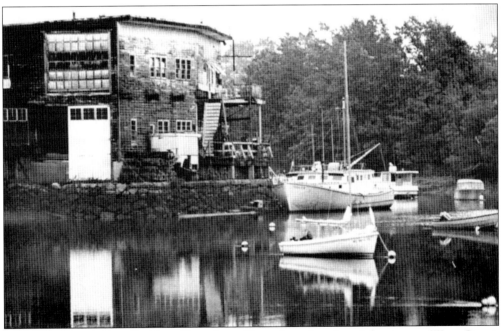

This is Melanson's Boat Building Shop that still stands at the edge of the river on Water Street. Although no longer active, during the 1970s it was the scene of a local renaissance of the ancient art of shipbuilding. Many modern fishing boats were built here and put out to sea.

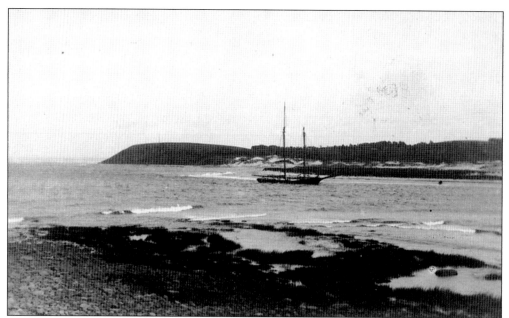

Here, from the mouth of the river on Little Neck, is a tall ship catching the tide to proceed upriver to the Town Wharf. Towlines from local steamboats were used to bring the ships to the wharf. Steep Hill Beach and Castle Hill are in the background.

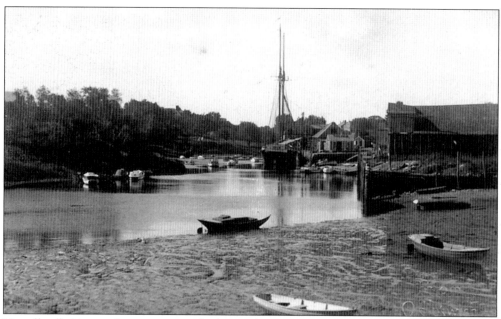

Not all tall ships made it upriver to discharge their cargo on the Ipswich waterfront. During the summer of 1891, the coal schooner *Lucy Collins* was wrecked on the Ipswich Bar, at a point known as Southern Spit. The 240 tons of coal, which was insured, was salvaged, and the rest of the wreck was purchased by a Gloucester company that stripped her of anything of value. The hull was left to sink into the sands of the Ipswich Bar, where it no doubt remains today.

Two

HISTORIC STREETSCAPES

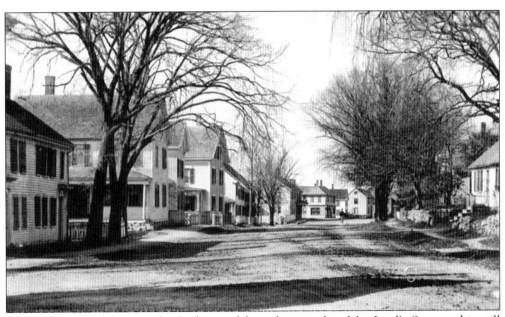

Although the buildings in the background have been replaced by Lord's Square, this still identifiable *c.* 1910 view shows High Street looking north from the intersection of Mineral Street. In the center of the background is the store and grog shop of Nat Burnham, who was also captain of the *Carlotta*, and just to the left of that is Asa Lord's store for groceries and East and West India Goods.

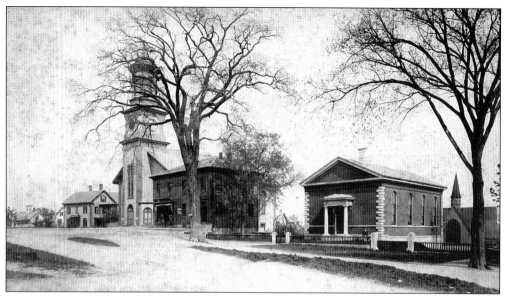

While this picture is over 100 years old, it is still easily recognizable as North Main Street in front of the Ipswich Public Library that was built in 1868 by Augustine Heard. Today the library has two new wings, and the nearby Methodist church has a handsomely reconstructed steeple that conceals a cell phone tower.

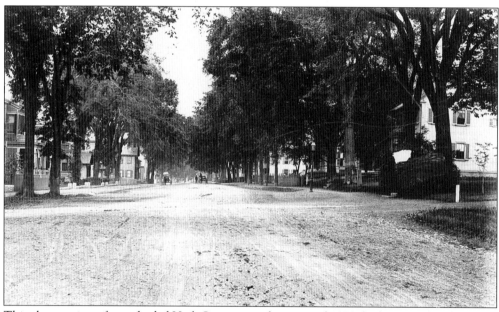

This elegant view of tree-shaded High Street was taken around 1900, looking north from North Main Street. The William Oakes house is on the right, and the current Whittier-Porter Funeral Home is on the left. It is said that during a shower one could walk under these umbrella-like branches from Lord's Square to North Main Street without getting wet.

This house at 3 High Street, for many years the Episcopal rectory, is known as the John Gaines house for its 18th-century builder. It was occupied in the early 1800s by horticulturist and educator William Oakes, who committed suicide by jumping off the East Boston railroad ferry. After his death, his widow supported herself by running a boardinghouse for students at the Ipswich Female Seminary. (Courtesy of Bill George.)

This c. 1900 view of the Glazier-Sweet house shows the streetscape on Water Street when it was just a footpath along the river. The path ended just beyond Dodge's Boathouse in the background. One reporter described this "Ninth Ward" neighborhood as being far from the Puritan morals of Ipswich's founding fathers, with some living without the benefit of clergy. At a more recent date, this house was the home of Nan and Bill George, who collected and loaned many pictures for this book.

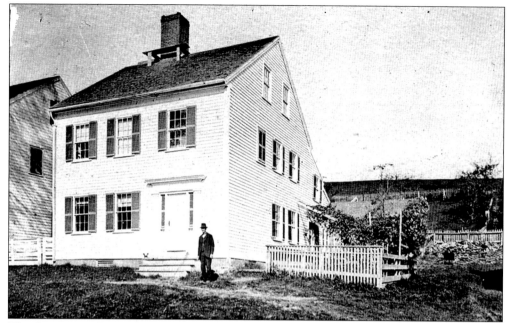

This home at 6 East Street was owned by Foster Russell and later by the Richardsons, who purchased the Ipswich News Company when it was on the opposite side of Market Street in 1938. Although the house looks much the same today, the grass in the foreground is now the middle of busy East Street. Perhaps this is proof of the often-heard comment of the early 1800s that "Ipswich is a town in decline with grass growing in the streets."

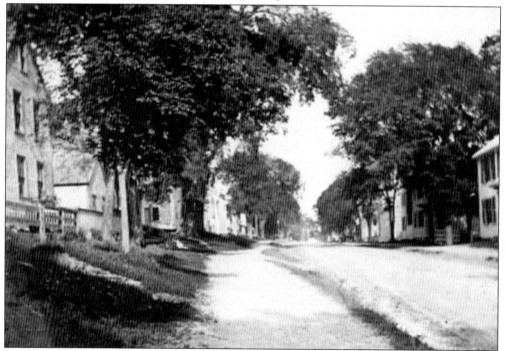

Here is High Street looking south. The Philip Call house, seen in this *c.* 1859 photograph, is the second house on the right and currently the home of Cathleen and Paul McGinley.

This shows the home of Ernest Currier at the corner of Hammatt and Central Streets. It was torn down and replaced in 1959 by the Immanuel Baptist Church. Currier was a real estate broker, responsible for the automobile dealerships on South Main Street, the evocation of the Ipswich Mill property, destruction of Ross Mansion, and the current Currier Park housing development.

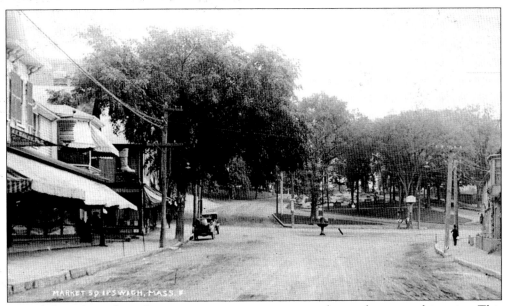

Ipswich has always been known as a quiet country town, but perhaps not this quiet. This early-20th-century postcard view shows Market Square at the foot of Town Hill. On the right is the front of the home of Miss Wait and her companion Miss Russell. After 1940, it was the home of the Ipswich Cooperative Bank. Today it houses Bernard Sullivan Insurance. On the left is Spiller's Shoe Store, identified by a sign in the shape of a large shoe, and Boylan's Drug Store, identified by a large mortar and pestle.

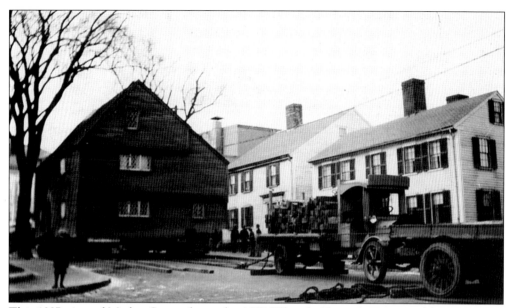

This 1927 view of Market Street shows the 1677 Whipple House being moved by its owners, the Ipswich Historical Society, from Saltonstall Street to its current home at the South Village Green. In the background are houses that were torn down in 1938 and replaced by the post office and later by the First National Bank of Ipswich.

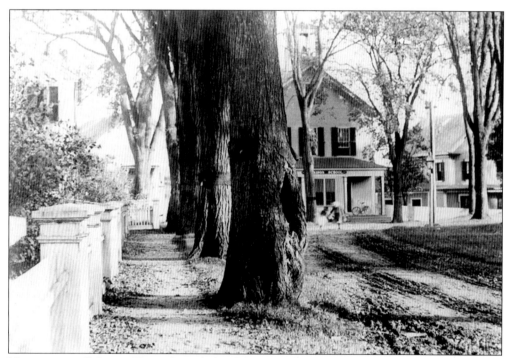

Here is a view of Meeting House Green behind the First Church. In the background is the Dennison School, which was closed and later torn down in the 1940s. (Courtesy of Bill George.)

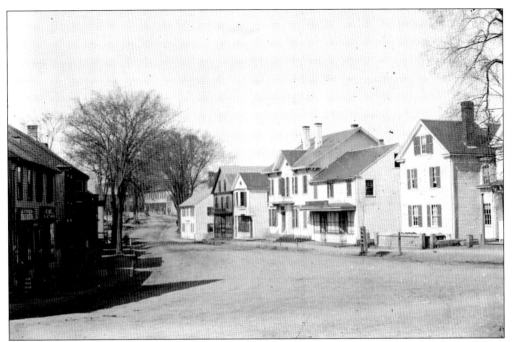

This is Market Street from Market Square, when it was mostly residential and these buildings had just a few first-floor storefronts. The first Damon Building that burned in 1894 can be seen at the Depot Square end of the street.

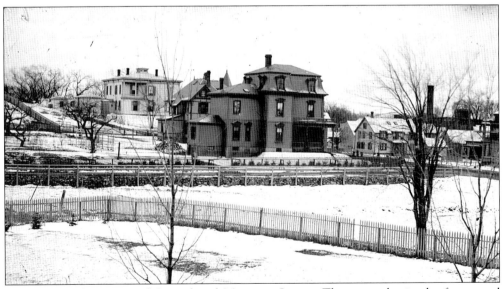

Seen here is the corner of Central and Manning Streets. The empty lot in the foreground became the site of the fire station, dedicated in 1908. On the corner is Dr. McGinley's house, which was later turned sideways and is now the first house on the right of Manning Street. Behind it is the Currier house, replaced by the Baptist church, and behind that is the house that is now the nucleus of Oak Hill Apartments. Across the street is a house that was moved to build the former Conley's Drug Store. However, the house is still standing in the alley that runs from Wildes Court to Central Street.

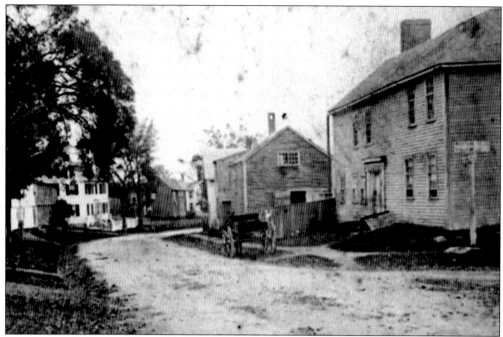

This 1870s stereopticon view looks down East Street from the intersection of North Main and High Streets. The 1737 Day-Dodge House is on the right, currently being handsomely restored, and the 1701 Matthew Perkins house is just down on the left. (Courtesy of Martha Varrell.)

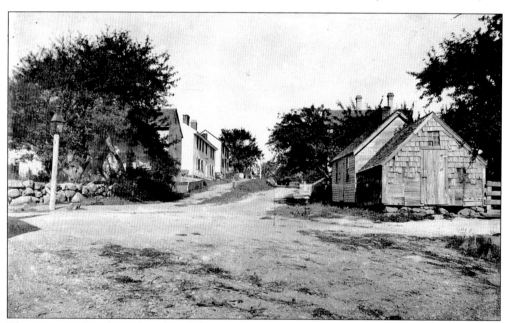

This view is taken from the edge of the Ipswich River at the foot of Summer Street, said to be the oldest "way" in Ipswich. Note the grade change on Summer Street. On the left is 1 of 16 streetlights tended by Moses H. Grimes. He lit them at dusk and turned them off at midnight, because, he felt, "at that hour good people were said to have no need for street lights and people still out at that time didn't deserve them."

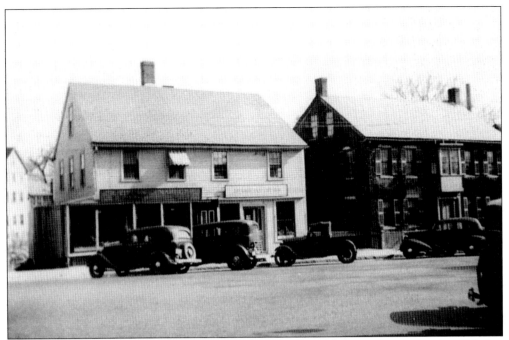

This view from the early 1940s shows two buildings still standing on the south side of Market Square. In 1941, the former Wait house on the right became the office of the Ipswich Cooperative Bank. The left side of the building on the left was Titcomb's Market, and for a long time, the right side was Jodin's Barber Shop, known for lively conversation and its display of old photographs of Ipswich. (Courtesy of Bill George.)

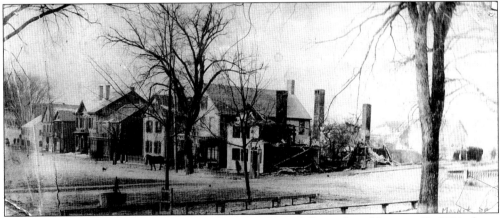

This view of Market Street, taken after the great Central Street fire of January 13, 1894, shows the combination of residential and commercial buildings on Market Street at that time. The mostly destroyed house on the corner, later the site of the Tyler Block, was the 200-year-old Heard Building that included several apartments and the office of physician and surgeon George E. McCarthy. He was said to have had an extensive drug laboratory in the building.

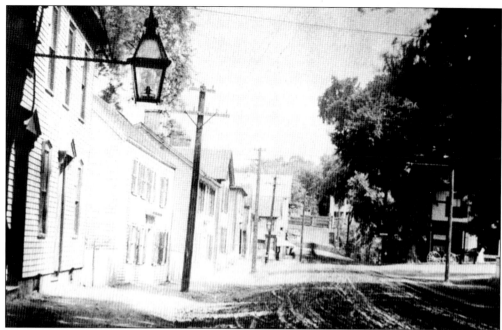

Here is South Main Street looking toward the Choate Bridge some time before 1909, when the street was still primarily residential. Many of these buildings that backed onto the Ipswich River were used as modest rental properties for the employees of the Ipswich Hosiery Mill. (Courtesy of Bill George.)

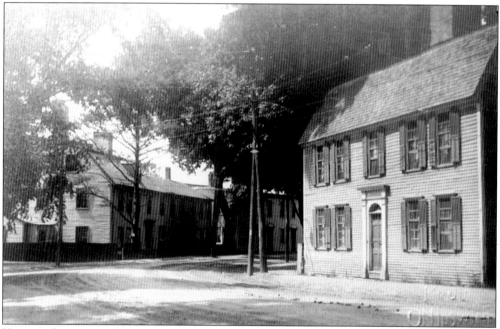

Here on the corner of South Main Street is the Sally Choate house. By this time, it was part of the Heard estate, which would eventually be purchased by the town. In 1944, with many Ipswich casualties after the invasion of Normandy, the site became the location of the town's war memorial.

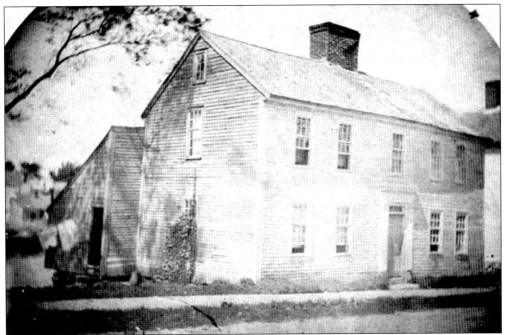

Although greatly done over, this is the Jones house, built by hatter and felt worker William Jones in 1726. He was related to Benjamin Franklin's wife, Deborah. During the preacher George Whitfield's great revival services of the 1740s, local lore has it that he stayed in this house. Some 50 years ago, this storefront was the shoe store of Gus Vlahos. (Courtesy of Martha Varrell.)

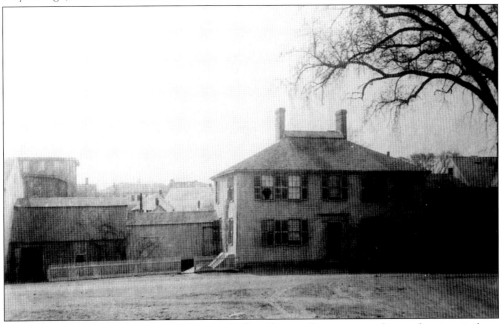

This scene shows South Main Street just before Ernest Currier started transforming it from mixed residential use to *the* local address for automobile showrooms and repair in 1909. If Ipswich was going to be a destination for automobile traffic, it had to have facilities to repair flat tires and overheated radiators.

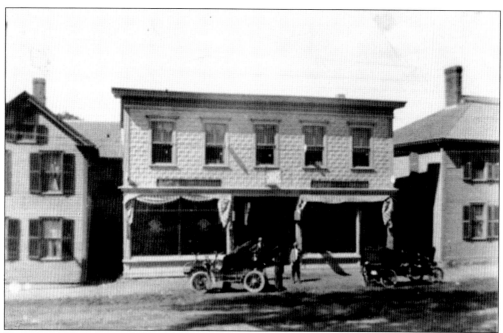

In 1909, Ernest Currier bought and tore down the historic Baker house and bakery on South Main Street to construct this building that was primarily a bicycle shop. With many tourists beginning to visit town with automobiles, he felt there was also a need to service their less-than-reliable horseless carriages and increasingly popular bicycles.

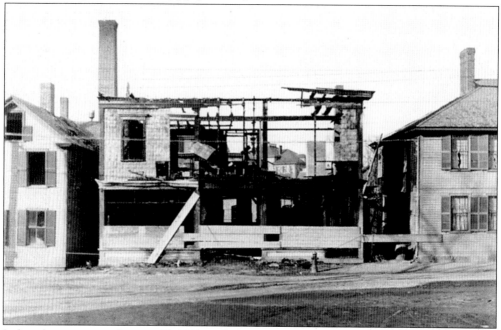

In less than a year, on January 25, 1910, at 5:30 a.m., an explosion and fire reduced Currier's new building, opposite the Elm Street intersection, to a charred ruin. The Currier family, who was living upstairs, escaped safely. The tin siding also limited damage to the impressive 1728 Joseph Manning house on the right.

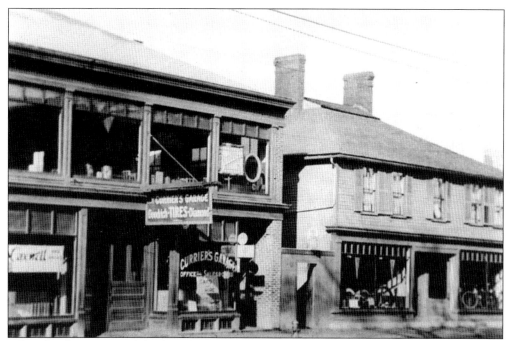

After the destruction of the bicycle shop, Currier built this very imposing building that was purchased by Dick Davis in 1915. The Manning house can still be seen on the right, with the first floor converted to stores. (Courtesy of Bill George.)

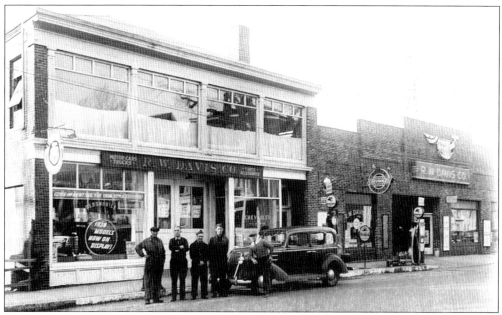

In 1922, the Porter brothers from Hamilton opened a Ford dealership just north of the Manning house, and later Dick Davis tore down that building and replaced it with the building shown here. That business ultimately moved to the current County Road site of today's O'Keefe Chevrolet. In 1960, Ben Collins bought the Ford business and in 1970 also moved to County Road, directly across the street from his Chevrolet competition. (Country of the Ipswich Public Library.)

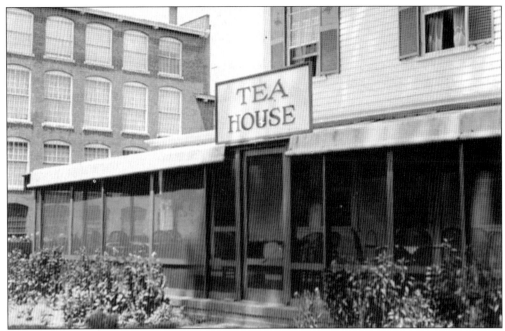

In 1922 the Ipswich Hosiery Mills opened a retail store in the former Philemon Deane House on South Main Street. The following year, it opened a tearoom next door in what had been Atherly's boardinghouse. These rather nondescript buildings were given extensive colonial restoration treatment by Topsfield historian and preservationist George Francis Dow.

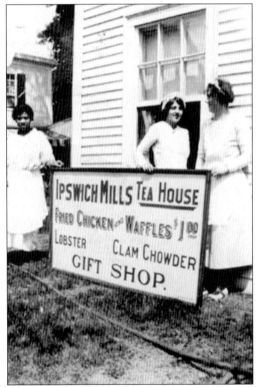

Rosamond Reilly Rice, a former Ipswich schoolteacher, and Thelma Bailey Carey, are the waitresses shown on the right. According to Carey, she was paid $3 a week, many of their customers arrived in chauffeur-driven cars, and a 10¢ tip was considered average.

Shown here in the 1920s is the Ipswich Mills Tea House, operated by Madeline Linehan, much as it looked until recently when the wall collapsed and had to be rebuilt to accommodate a new footbridge across the river. In 1980, this building and the building next door that formerly housed the Ipswich Mill Hosiery Shop were remodeled to become headquarters of the Quebec-Labrador Foundation.

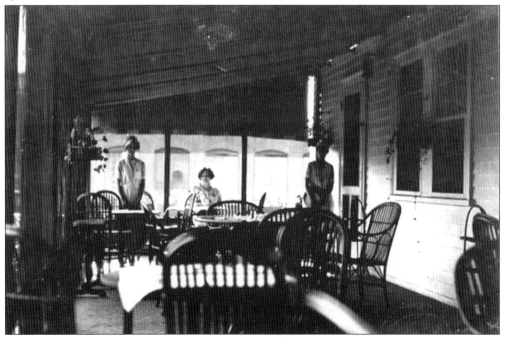

In 1923, this attractive porch dining room at the Ipswich Mills Tea House became a popular magnet for tourists on a day's outing to visit Ipswich and learn of its historic past.

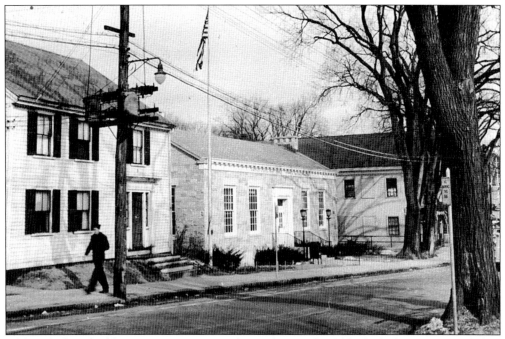

Although there had been many arguments about where it should be built, by 1939 Ipswich had a new post office on Market Street.

This is a very old view of Market Square. In the background, the First Church parsonage is on the left, and the Ipswich Female Seminary building is in the center. This picture was taken before 1891, when the Jones Block was built on the seminary's lawn.

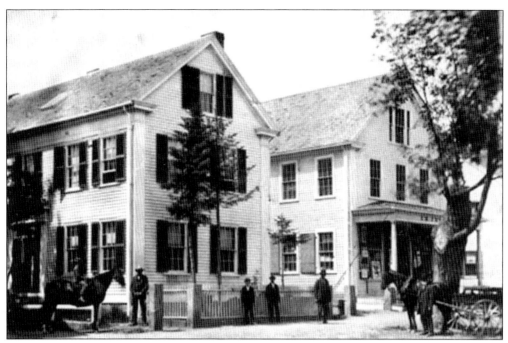

Here on Market Street are the Jewett homestead and the store of Israel K. Jewett, known to all as I. K. His store later had a number of other tenants, including Plouff Metal workers and Charley Mourikas, who operated the Ipswich Spa and Ice Cream Parlor. Both buildings were torn down in 1935 and replaced by a building that housed Woolworth's and the A&P.

For over 150 years, this building has anchored Ipswich retail trade at the south end of the Choate Bridge. At one time, it was home to Newman's complete stock of home furnishings, featuring lamps, tableware, fine china, and glass, as well as pumps, stoves, and iron sinks. For the past 30 years, the right side has been home to Immie Thayer's bridal shop.

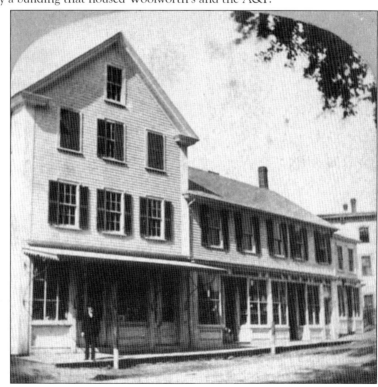

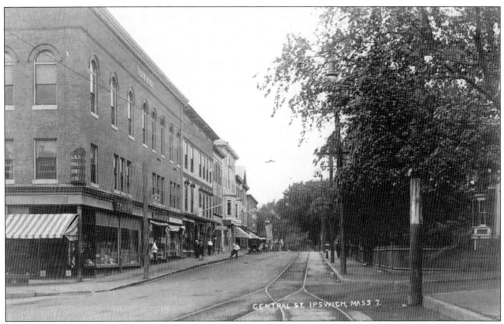

This view of Central Street from Market Square reflects early-20th-century prosperity with the grand Tyler's Department Store on the left and the tracks of the Georgetown, Rowley, and Ipswich Street Railway that operated from 1900 to 1919 in the center of the picture.

Shown here in the early 1900s is the hill south of the new Ipswich Power Station, just opposite the current electric company office building. Careful observation shows the then new trolley car tracks sort of drunkenly drifting down hill. The smokestack of the new power plant can also be made out on the center horizon.

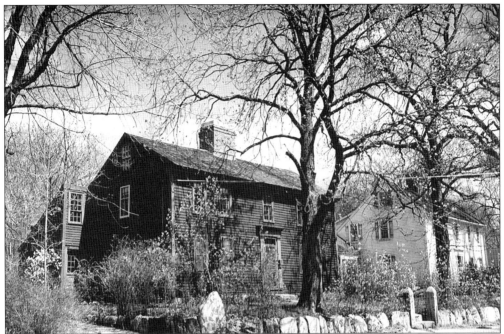

This First Period house, known as the John Kimball House, was called "The House of Oak and Pine" by Ralph Burnham. Believing that the furniture and accessories of his extensive antiques business were shown to best advantage in a home setting, he bought and restored a number of Ipswich houses to use as showrooms. This was one of the properties in which the Kotek brothers developed their skill in removing layers of paint and wallpaper from antique paneling.

Still relatively easy to recognize after almost 100 years is this view of East Street, taken in 1909. According to the identification written on this picture, the Damon House is on the left. There are no longer as many trees on what is still a major thoroughfare to the east end of town. By 1909, this view down one of the oldest streets in town had been marred by telephone poles.

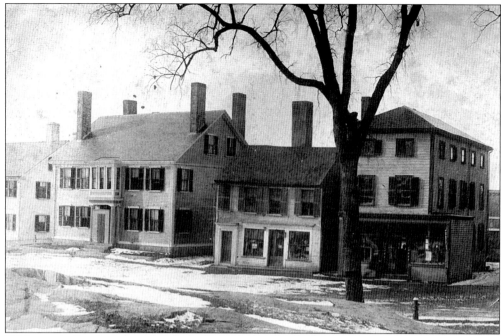

If Measure's Candy Store is read about, it was recorded that it occupied two locations. Here it resides in the smaller of the two buildings that were moved to build the Colonial Building, still standing on North Main Street. The larger building contained a social hall used by the Independent Order of Odd Fellows before they moved to the building next to the Ipswich Public Library.

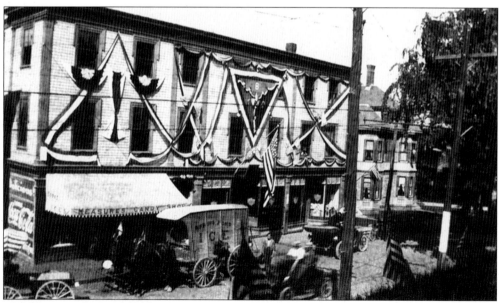

This lively picture of a building still standing on Central Street shows the second home of the Measure's Candy Store in what was then called the Measure's Block. This was one of the buildings that replaced those destroyed in the great Central Street fire of January 13, 1894.

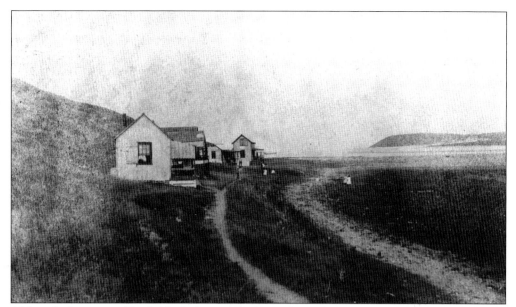

Although this view of Little Neck shows only footpaths, today's picture of the same area would show River Road. Seen here are several of the original cottages, the mouth of the Ipswich River, Castle Hill, and Steep Hill Beach in the background.

While this streetscape reflects the earliest days of local history, that era was, of course, before the days of photography. This scene reflects a colonial village temporarily recreated on Choate Island in 1995 for the Hollywood filming of *The Crucible*.

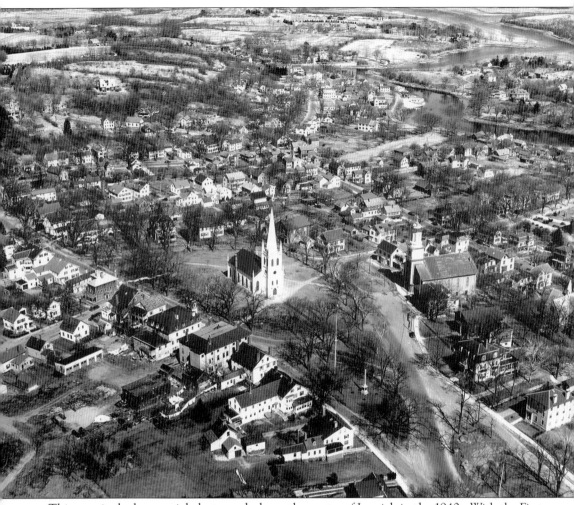

This amazingly sharp aerial photograph shows the center of Ipswich in the 1940s. With the First Church as its centerpiece, one can easily follow the old roads that appear much the same today. It is surprising that there was still so much open land in this early neighborhood that was first settled by Puritans in the 1600s when everyone was required to live within a half mile of the church. (Courtesy of Jane and Ben Collins.)

Three

BYGONE BUILDINGS

This County Road landmark, with double front doors, was known as the Albert Storey Brown House, built around 1840. In 1934, it was converted to apartments, and after the addition of two wings, it burned on January 31, 1993, in a fire that left 23 people homeless. This building was located on the corner of the current driveway to the Ipswich YMCA. (Courtesy of Bill George.)

This site at the wharf end of Water Street was originally the home of reputed wrecker and pirate Harry Maine. Wreckers built bonfires to lure unsuspecting ship crews to run aground on the treacherous shores in order to plunder their cargo. Harry Maine was thought to have buried so much pirate gold on his property that later, renters and others dug up every inch many times over.

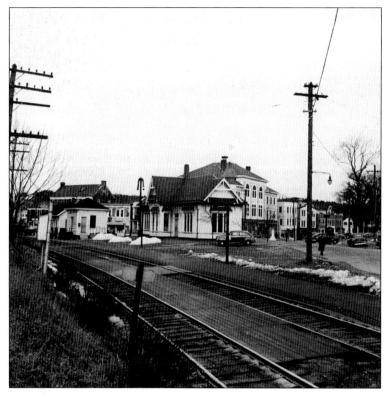

In 1900, Depot Square presented a scene of rural prosperity with a brick hotel, a relatively new railroad station, and a Victorian retail palace in the form of the second Damon Building. However, by 1943, when this picture was taken, the scene was beginning to look a bit gritty. The Damon Building lost its roof and third floor to fire in 1946, the station was torn down in 1959, and the Hayes Hotel burned in 1969.

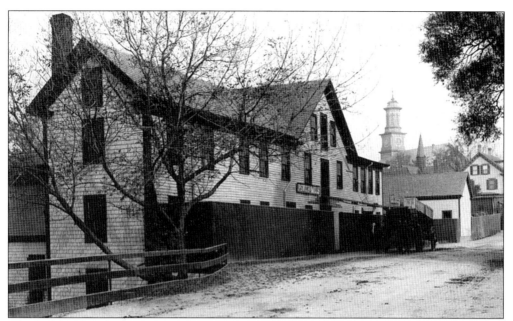

This building beside the County Street Bridge was built in 1863 as part of the Ipswich Woolen Mill. After the mill went out of business in November 1886, it became a warehouse for the Ipswich Hosiery Mill. When that mill closed, it was torn down and later became the site of the Congregational parsonage. Note the steeples of the Episcopal and Methodist churches in the background, the Methodist steeple being the taller of the two. (Courtesy of Martha Varrell.)

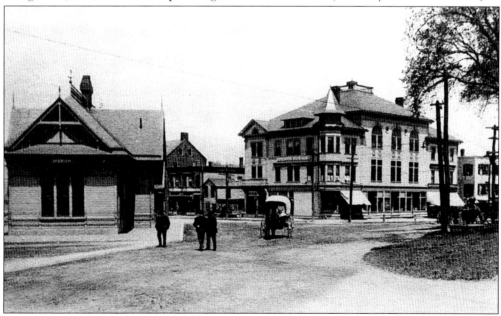

Another example of local prosperity was the buildings at the Depot Square end of Market Street. In addition to the substantial railroad station built in 1884, the second Damon Building was constructed to replace the original that burned in 1894. With the brick Hayes Hotel also located in Depot Square, visitors stepping off the trains easily realized that Ipswich was "more than just a wide place in the road."

This is the Mitchell farm that gave its name to Mitchell Road, which runs from the Dairy Queen on High Street to the Ipswich Industrial Park. The house on this property, last farmed by John Hetnar, is still standing but significantly changed.

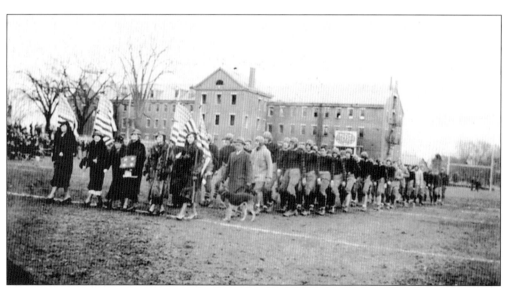

This scene represents the Armistice Day celebration in 1934, prior to a football game between Ipswich and Rockport. The missing windows in the jail indicate that its demolition had just begun. Prior to its destruction, Ralph Burnham had used the empty cellblocks as storage space for his inventory of historic building parts, of which he was a national dealer.

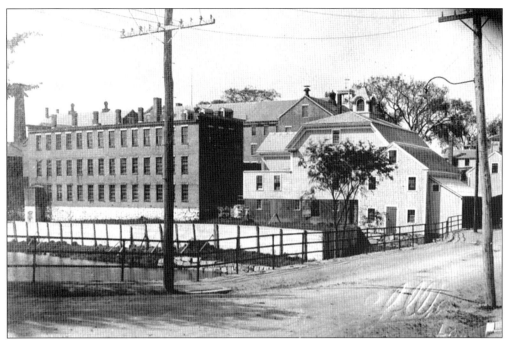

When the Essex County Jail was in full operation in the late 1870s, a significant attached farm was required to feed its inmates and employees. This scene from the Green Street Bridge shows the large wooden barn where the horses and cows were kept. The three-story building on the left is still standing and is currently being converted into apartments. (Courtesy of Bill George.)

Shown here is the Essex County Jail and jailer's house, built in 1846, at the site of the current Ipswich Town Hall. One wing of this building was originally used as a jail; the other was used to confine the insane. As an economy measure, women were no longer kept here after 1886 when the federal eight-hour law required that all female prisoners be supervised by three eight-hour shifts of matrons. (Courtesy of Bill George.)

This is Asa Lord's Store in Lord's Square shortly before it closed around 1930. Opened in 1826 with stock purchased with $200 worth of credit, its upstairs stockroom was said to have been "a regular museum with goods of every kind piled in the wildest confusion." When it was cleared for the last time, it reportedly contained goods dating back to before the Civil War. Its back ell was moved to Mount Pleasant Avenue and became the Bokron residence.

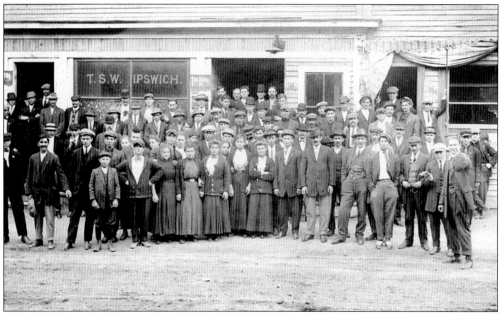

These Polish mill workers are gathered in front of their Saint Lawrence Society headquarters on Estes Street during the 1913 mill strike. There are two pictures of this group, one with just men and this one that shows women asserting themselves. Thanks to Doris Dudeck of Kimball Street, it is now known that two of the women are her mother, Agnes Pryzbylo, and her mother's friend Maggie Galaska.

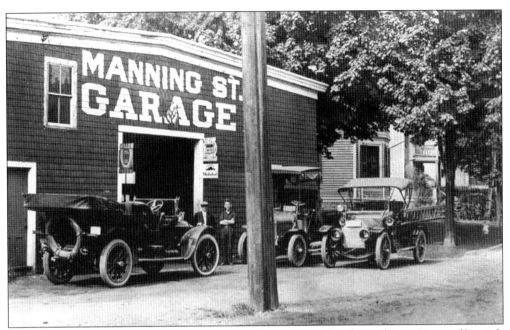

The Manning Street Garage was operated by Arthur Mayer of Rowley and Peter Porter of Ipswich and did business as Mayer and Porter. After about five years on Manning Street, they needed more space and moved to the building on Hammatt Street formerly used by James Graffum, carriage builder, now the home of Agawam Auto and Hardware.

This is the Barowy farm on High Street, previously Dole's Dairy Farm, which was torn down to construct a new Ipswich High School. The school was first proposed in 1953 and finally built in 1962. That building was torn down in 1999 and replaced by the current Ipswich High and Middle School.

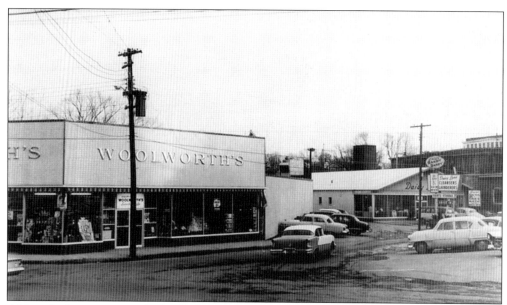

Although this picture at the corner of Union Street does not appear to be very old, the two buildings on the left are gone. Woolworth's, built in 1959, was torn down in 1996. The Daisy Lane Cleaners, opened in 1959, was a business that had formerly occupied half of the Ipswich Railroad Station. After the laundry went bankrupt in 1963, Bill Wasserman bought the building, and the right side became the home of the *Ipswich Chronicle*. The left side was later Bogatti's Sub Shop.

This is the Jones Block that climbed Town Hill between Market Square and the former Ipswich Female Seminary building. Built in 1891, it was torn down in 1973 and replaced by the Christian Science Sunday school building.

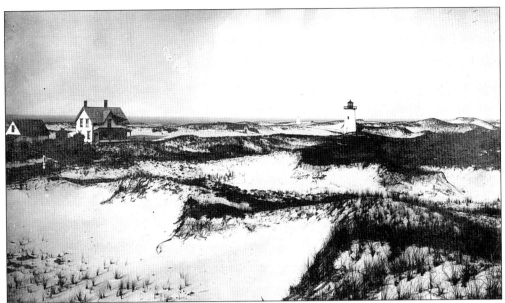

This picture shows the relationship between the Ipswich lighthouse that was moved to Edgartown in 1939 and the lighthouse keeper's house that burned in 1977. The keeper's residence was located at the edge of the Ipswich residents' parking lot for Crane Beach, first built in 1934. Constructed on a former cranberry bog, it was often flooded and had to be completely rebuilt a few years later. Although allowing only minimal privacy, in its final years this residence could be rented by local residents for only $10 a day or $25 for three days.

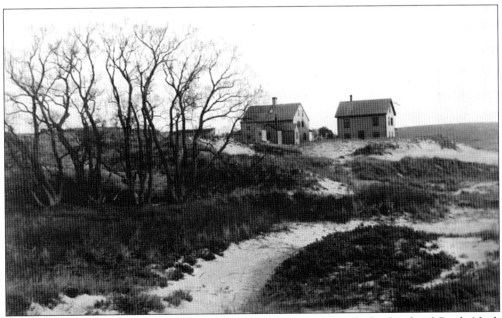

This shows the rear of G. Loring Woodbury's boardinghouses on the back side of Castle Neck and facing Choate Island. Part of the property purchased by Richard T. Crane in 1910, one of the buildings burned in October 1913, and the other burned in June 1916 while being used as a dormitory for men who were building the Crane Estate on Castle Hill.

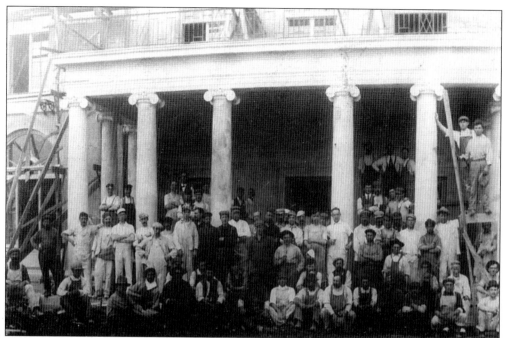

There have been two Crane mansions at Castle Hill, the first of which Richard T. Crane's wife, Florence, did not like. Seen here in 1914, just before construction was completed, are the builders in front of the first Crane mansion, on the ocean side of the house, with its Ionic columned porch. The building was torn down in 1925 in order to build the current Stuart-style "Great House." (Courtesy of Bill George.)

This is the Castle Hill summer home of Ipswich native John Burnham Brown, who had greatly enhanced his ancestral property with landscaping and carriage roads (open to the general public) prior to its purchase by the Cranes. In 1904, he had even constructed two public bathhouses on the property. Named for him, this building was part of the original Brown Cottage, now an upscale bed-and-breakfast.

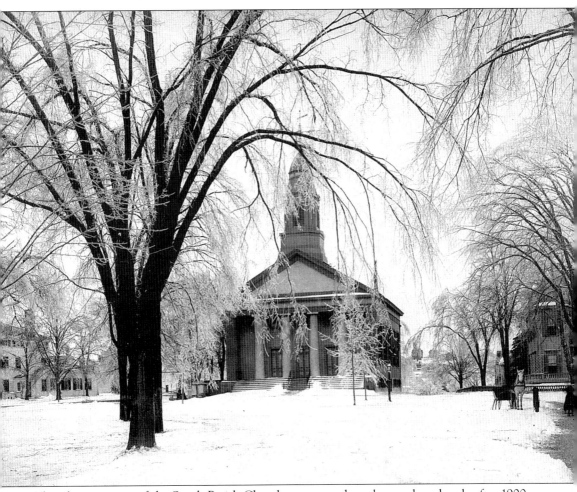

This classic picture of the South Parish Church appears to have been taken shortly after 1900. It was definitely taken after 1899, when the remodeled church steeple was struck by lightning, burned to the bell deck, and later rebuilt as originally constructed. The church building, which was also used as a youth center, burned in 1977. Only the foundation and bell remain today. The Heard House, headquarters of the Ipswich Historical Society, is on the left. The former Swasey Tavern, where George Washington had lunch in 1789, is on the right.

This is the building of the Ipswich Female Seminary on the right side of North Main Street. It was originally founded as a classical academy for both boys and girls in 1826. Two years after opening, it became one of the first female boarding schools of higher education in America. It educated young women from most states east of the Mississippi until it closed in 1874. One of its principal teachers, Mary Lyon, went on to found Mount Holyoke College in South Hadley.

With the addition of a Victorian mansard roof, this is the seminary building just before it was torn down in the spring of 1930 and replaced by the Christian Science church. After the school closed, its auditorium was used for lectures and social functions, and it housed many businesses, including that of photographer George Dexter, who was burned out of his Central Street studio in 1894.

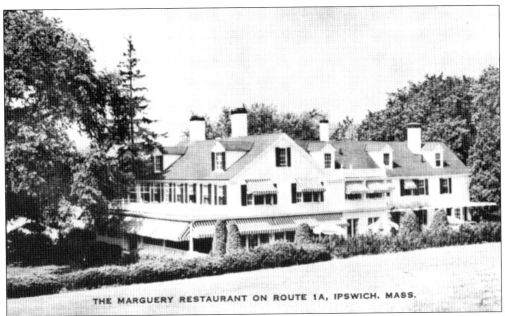

THE MARGUERY RESTAURANT ON ROUTE 1A, IPSWICH. MASS.

The Marguery restaurant was formerly the Barnard estate called Riverbend, on County Road. Built by George E. Barnard, it was a showplace with handsome landscaping that stretched to the Ipswich River. Opened in 1949 as a restaurant by Jane Marchisio, it was one of the finest eating places on the North Shore. After a number of suspicious small fires under new owners, it was totally gutted by fire in September 1975. Only the parking lot remains on County Road.

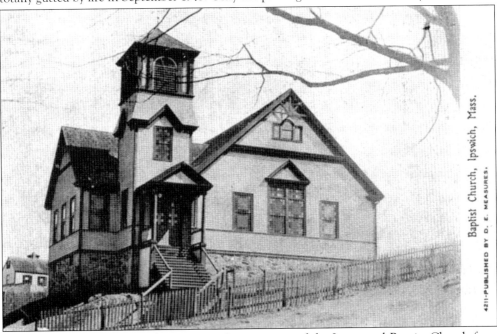

Baptist Church, Ipswich, Mass.

4211-PUBLISHED BY D. E. MEASURES.

This building just off Central Street was the sanctuary of the Immanuel Baptist Church from the time it was built in 1898 until it was replaced by the current building in 1961. Later called Spaulding Hall and used as a Sunday school building, it was burned by vandals in July 1976. This is now the site of the Oak Hill Apartments. (Courtesy of Martha Varrell.)

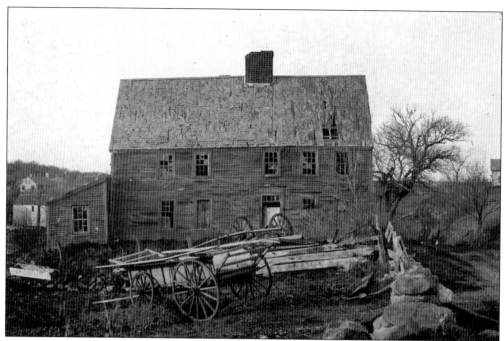

This First Period building on Tansy Lane near the corner of Turkey Shore and Labor-in-Vain Roads was known as the Hovey House, built in 1667. Last used to store hay, it burned in 1894.

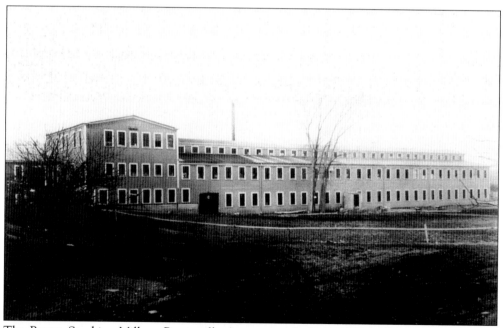

The Brown Stocking Mill on Brownville Avenue was built in 1907 by Harry Brown, former supervisor and agent of the Ipswich Hosiery Company on the river. After financial difficulties, this hosiery mill closed in 1914. Later occupied by the Burke Heel Company, Beswick Engineering, and the Pierce Furniture Company, among others, it was recently torn down, and the site was developed for housing. (Courtesy of Bill George.)

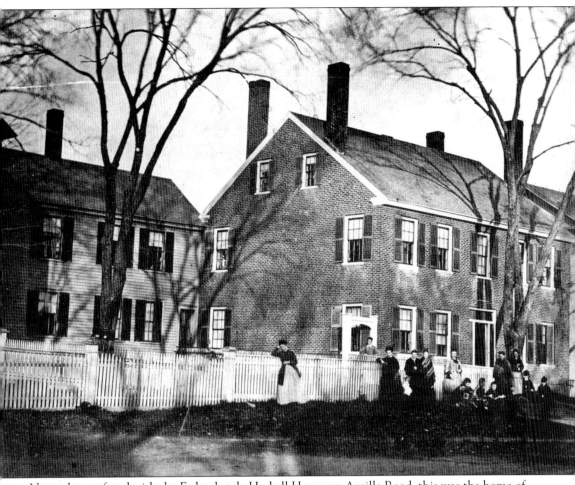

Not to be confused with the Federal-style Haskell House on Argilla Road, this was the home of undertaker and upholsterer George Haskell at 1 High Street, opposite North Main Street. It was torn down by Harry Brown, who wanted more room around his home, the Roger's Manse, next door. The salvaged bricks were used to build the brick house at Brown Square. (Courtesy of the Barton Collection, IHS.)

This building beside the Choate Bridge was assembled from several old barns by antiques dealer Ralph Burnham and called the Galleries, a gallery of contemporary art. It was his dream to convert it to a business to be called the Tuck-a-way Tavern, but by the time Prohibition ended, his health had deteriorated too far to realize that dream. It was torn down and replaced by a building with similar architectural elements, now the office of Caldwell Banker Real Estate.

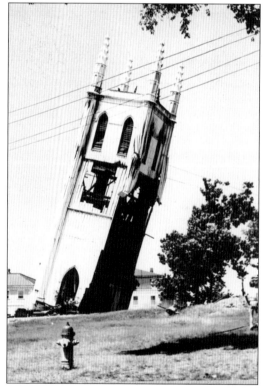

On June 18, 1965, the fifth building of the First Church of Ipswich on Town Hill was struck by lightning. Although the walls and steeple remained standing, they were so completely gutted, they had to be taken down. This Elmer Copperthwaite photograph shows the Gothic steeple just as it was beginning to fall.

This small industrial building on High Street was a temple of Ipswich history. It was here that Benjamin Fewkes, with a knitting frame smuggled out of England, first manufactured Ipswich hosiery in 1822. In a dangerous, dilapidated condition, the building had to be torn down in 1983.

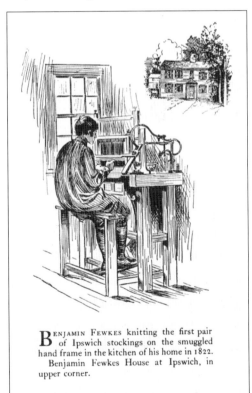

This is one of a series of nine different postcards created so that Ipswich tourists could send home a souvenir of Ipswich's industrial origins. The hosiery shop was in the small shop just visible on the left side of the house. (Courtesy of Martha Varrell.)

BENJAMIN FEWKES knitting the first pair of Ipswich stockings on the smuggled hand frame in the kitchen of his home in 1822.
Benjamin Fewkes House at Ipswich, in upper corner.

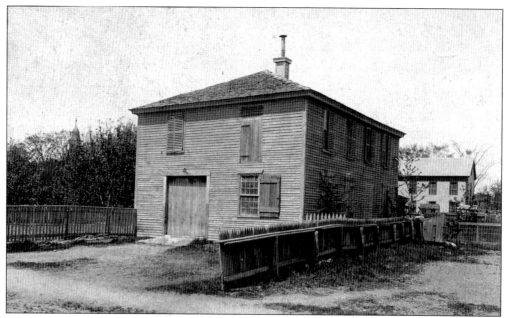

This building, which appears to be a barn, had previously served as the town's high school for 80 years. Built in 1794 in what was called the school orchard at the corner of County and Argilla Roads, it was described as a "handsome edifice" in 1798. Moved to its final location at the corner of Argilla Road and Payne Street in 1835, it was the town's seat of higher learning until the Manning School was built as a symbol of civic pride on the new Central Street in 1874.

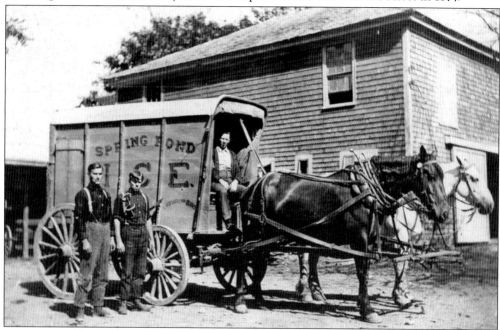

Here are the Lathrop brothers, Charlie and Wally, owners of an ice, coal, and oil business, who are standing beside their ice wagon with the former high school in the background. Later sold to Russell Grant in 1953, it was torn down in 1955 to allow more room for a parking lot at Grant's seafood restaurant. (Courtesy of Jane Collins (née Lathrop) and Ben Collins.)

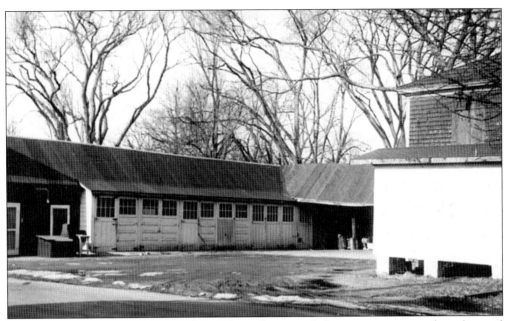

These are garages at Lathrop Brothers, where they stored their private cars and trucks until their business moved to Brown Square. The far end of the garages were used as a distribution center by Cushman's Bakery. From their headquarters in Lynn, they would move large quantities of bread, cakes, and cookies to Ipswich, where they would be transferred to smaller home delivery trucks.

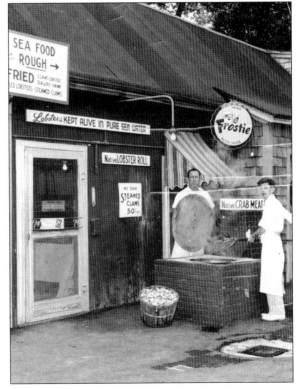

This is Grant's Seafood Mart, which was built from the former Lathrop brothers' garages. It was originally a business where local fisherman Russell Grant sold just clams and lobsters "to go." In 1955, Grant stopped fishing to concentrate on the restaurant, which operated from 1955 to 1969. Seen here is his son Billy, who, from a young age, had charge of the clam and lobster sales when lobsters sold for 59¢ a pound. (Courtesy of Billy Grant.)

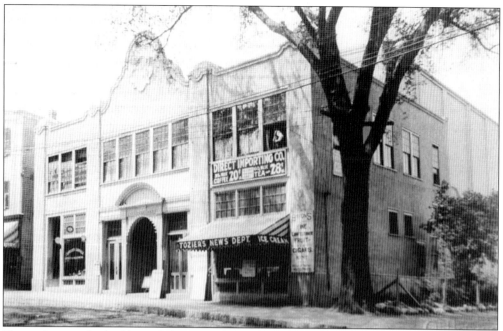

Shown here is the building of the Ipswich Opera House, built by the ever-industrious Byron family in 1909. This very grand building for such a small town was the home of sophisticated theater, from traveling stock companies, opera, and vaudeville, to the Boston Symphony Orchestra. After a fire in 1932, it was repaired and reopened as the Strand Theater.

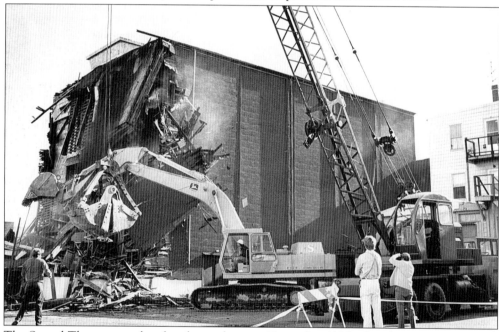

The Strand Theater was closed and torn down in November 1985, after the property changed hands and the distribution policy of major film producers made it impossible for small independent movie theaters to survive. An addition to the First National Bank of Ipswich now occupies this site.

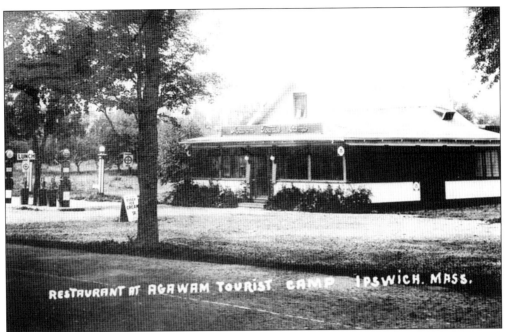

RESTAURANT AT AGAWAM TOURIST CAMP IPSWICH. MASS.

This building, now a private residence at 129 County Road, was built in 1924 as the Agawam restaurant owned by Valina Porter and her companion, Mildred Loveys. The business originally included gas pumps, which were discontinued in 1931 in favor of more parklike landscaping that extended to the river.

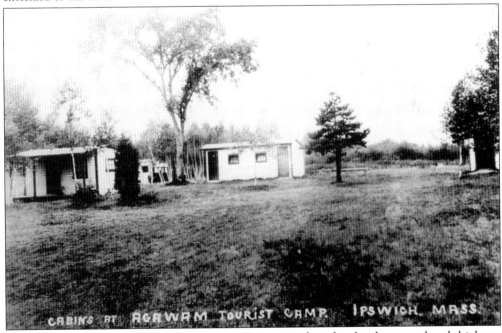

CABINS AT AGAWAM TOURIST CAMP IPSWICH. MASS.

These are the tourist camps of the Agawam Campground, said to be the second such highway business in New England. Originally just tent platforms, they evolved into small buildings with screened porches and running water. The business was sold in 1942 when gas rationing made it too difficult to conduct a business based on highway travel. (Courtesy of Bill George.)

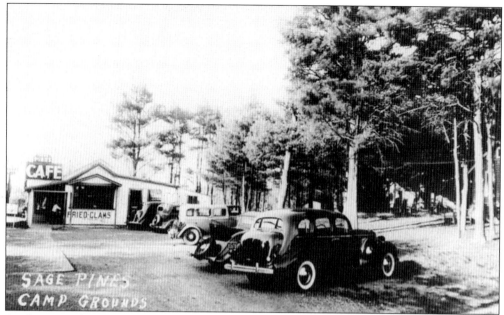

At the time when the Newburyport Turnpike (also known as Route 1) was the main highway between Boston and points north, this business was operated by Harriet LaSage as a tourist camp, restaurant, and dance hall. The LaSages are among the many who claim to have had some of the first fried clams in Ipswich. In 1969, the property was purchased by Kenneth and Pauline Hein, who added an additional 17 cabins. They closed the cabins in 1986.

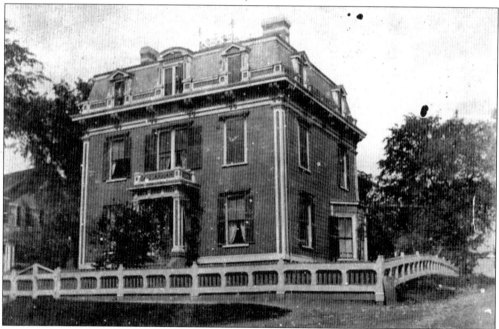

This is the Bancroft House, built by shoe manufacturer George Bancroft, at the corner of Saltonstall Street and Topsfield Road. At the time of the Ipswich Mills strike, it was a fruit store and a coffeehouse that was raided for being a bar. Later it was a Greek-run hotel known as the Parker House. By 1933, it was the site of the Strand Diner across from the railroad station.

Four

INSIDE FAMILIAR WALLS

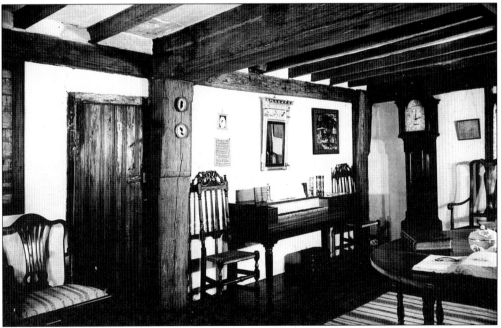

Known as the Parlor Chamber, this room is on the second floor of the Ipswich Historical Society's Whipple House. Although some of the furniture has been changed over the years, the piano remains, and the chamfered summer beam, posts, and floor joists appear much as they did when the house was built in 1677. The society used this room as its office and meeting room in the early days.

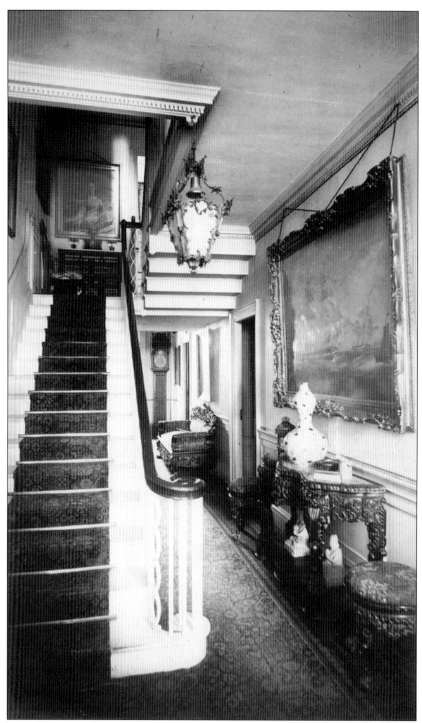

The Chinese Chippendale stairway in this 1900s photograph is certainly the focal point of the entrance hall of the Heard mansion, built by John Heard between 1795 and 1800. Headquarters of the Ipswich Historical Society, and looking much the same today, this hall is currently a portrait gallery for paintings of its builder and his family.

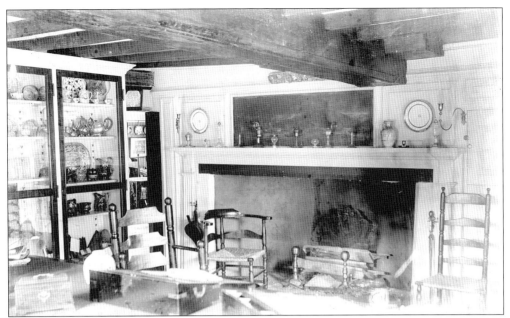

Shown here as it appeared shortly after the Whipple House opened as a house museum in 1898 is the hall. At that time, the room had Georgian paneling installed during Mary Whipple Crocker's occupancy. Today the summer beam and ceiling remain the same, but during the 1953 renovation when the house was returned to its First Period appearance, the display cases were removed to the third floor of the Heard House, and the overmantel painting of the Little Neck fishing stations was moved to the parlor.

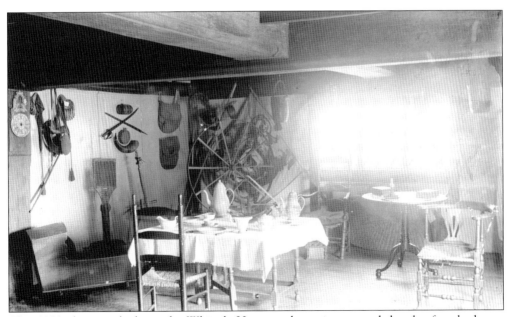

This 1900 photograph shows the Whipple House parlor as it appeared shortly after the house museum opened to the public in 1898. Today the miscellaneous collection has been replaced by authentic First Period antiques, many of Ipswich origin.

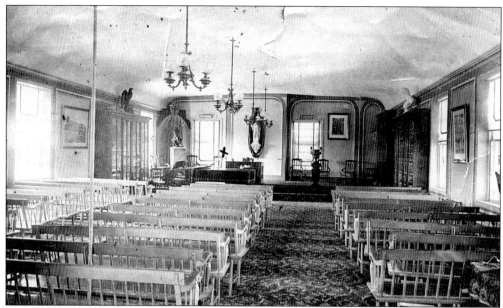

This 100-year-old view shows the vestry of the Methodist church, still used for many church social functions and religious services when the main sanctuary is too difficult to heat.

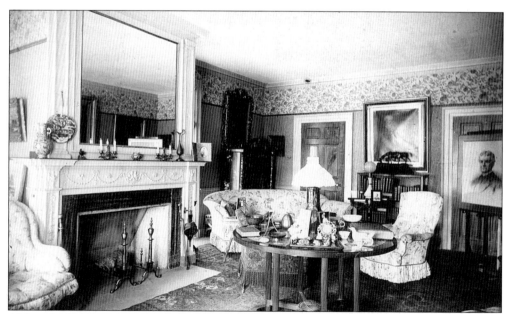

Although four generations of the Heard family occupied their ancestral homestead (now headquarters of the Ipswich Historical Society), by 1900 the Federal-style mansion was furnished by this collection of furniture and Victorian bric-a-brac. The painting on the easel is of George Leeds, a Heard family in-law. The painting of Augustine Heard hanging between the two doors can now be seen at the Ipswich Public Library.

Shown here is the interior of the South Congregational Church where the Rev. Thomas Franklin Waters, founder of the Ipswich Historical Society, was pastor from 1879 until 1909. Built in 1838, it reunited with the First Congregational Church in 1922, and it was used as the parish house.

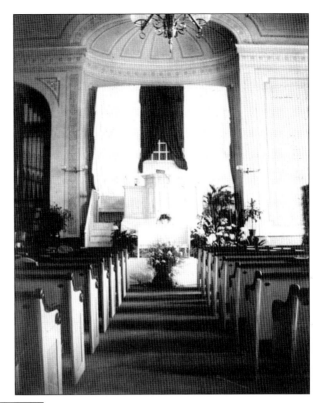

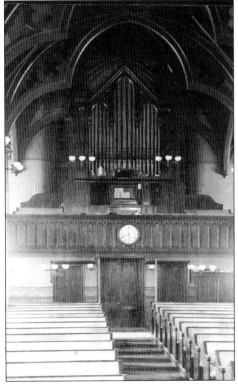

This organ in the choir loft at the back of the Gothic-style First Church, built in 1847, was purchased with funds donated by Augustine Heard. Located at the base of the steeple, this area received the most damage when the church was struck by lightning on June 18, 1965, and burned beyond repair.

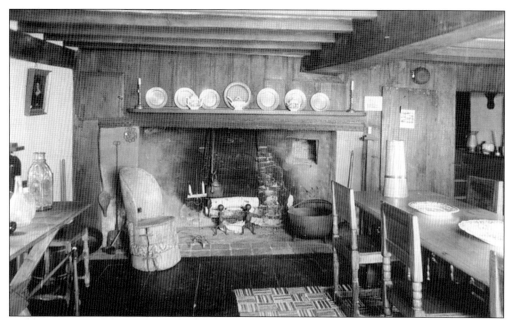

This is a room at the Hart House that New York's Metropolitan Museum declared one of the finest First Period rooms in New England. Copied for their museum in 1925, they came back in 1936 and purchased the original, that corner of the house being replaced by a reproduction that stands today. Another room in that corner of the house is now part of the Winterthur Museum in Delaware. (Courtesy of Martha Varrell.)

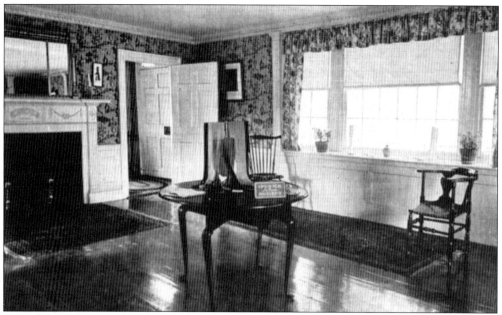

Although this appears to be a formal dining room, it is the sales room of the Ipswich Mills Hosiery Shop that opened in 1922 in the Philemon Dean House on South Main Street. Now an art gallery, this building was not as charming and attractive until it was remodeled with dormers, bay windows, and antique interior trim by Topsfield historian and preservationist George Francis Dow. (Courtesy of Martha Varrell.)

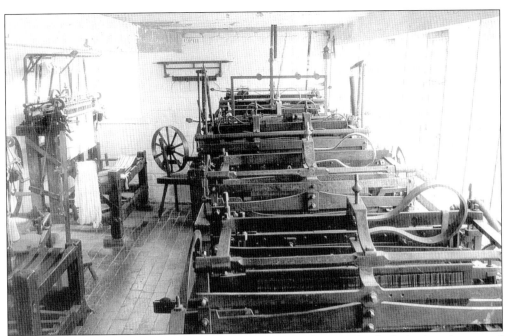

This is the interior of an unidentified local textile mill. Unfortunately, the lack of employees and the absence of the overhead belts used to transfer power to the looms and the incessant noise fail to fully represent the hectic 12-hour work environment endured by the local mill works. (Courtesy of the Town of Ipswich.)

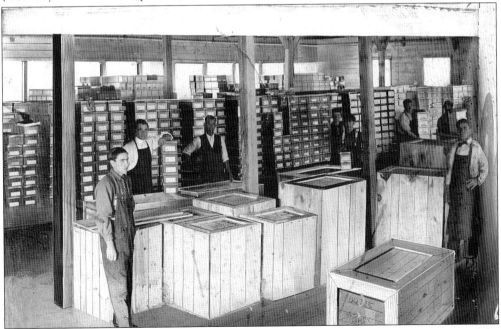

Of all the jobs at the Ipswich Hosiery Mill, a position in the shipping department was one of the most desirable. It is said that the most recent immigrants were given jobs in the dye house and came home every night "black" from the less-than-colorfast dye. But the shipping department was clean and free from the pounding noise of the knitting machines.

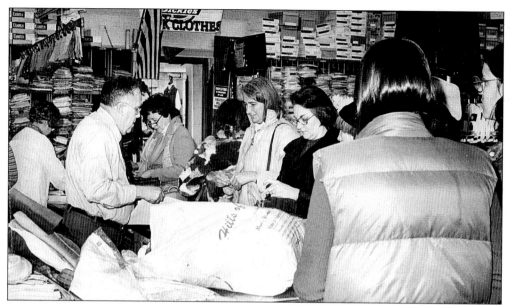

Hills Department Store on Market Street, first opened in 1929, was last owned and operated by Howard "Taffy" Hill and his brother Wendell. Here is Wendell waiting on customers just before the store was destroyed by fire in 1980. Although known for quality, name-brand merchandise, after the fire they had a real fire sale. The buildings were almost totally destroyed, but some sale merchandise was still encased in ice, and other items had been packed so tight, only the folded edges were slightly singed.

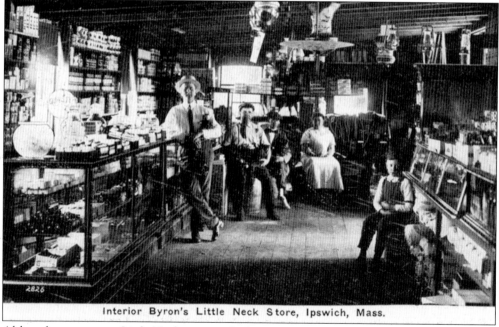

Interior Byron's Little Neck Store, Ipswich, Mass.

Although summers on Little Neck in its early days as a resort were somewhat Spartan, Byron's Store at the Little Neck Hotel was the only place to buy absolute necessities. This 1910 interior view shows "the place" to get caught up on the news. Byron's was the epitome of one-stop shopping. (Courtesy of Martha Varrell.)

Five

OLD BUILDINGS WITH NEW FACES

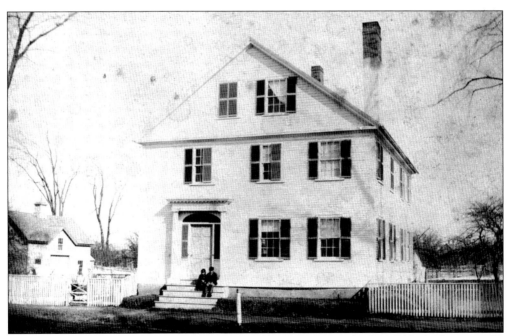

This Greek Revival home next to the South Village Green was built in 1831 by housewright Samuel Waite for his own residence. If it is unrecognizable, that is because the handsome front doorway was replaced by less impressive entrances on either side of the house. For practical purposes, the family stable in the background would be less charming by today's standards because of the requited manure pile under the bedroom windows and the need to care for the horse.

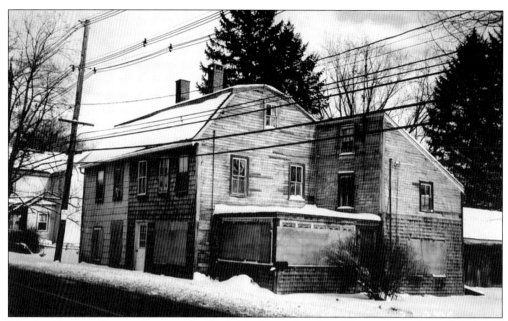

This building on County Street is the 1725 Abraham Knowlton House, shown here abandoned during a lengthy dispute over whether it was to be torn down to allow the expansion of the Caldwell Nursing Home or restored to preserve the streetscape in this historic part of town. In 2003, it was restored and converted to condominiums by Ipswich architect Matthew Cummings, once more enhancing Ipswich's claim to having more First Period homes lived in than any other community in America. (Courtesy of Paul McGinley.)

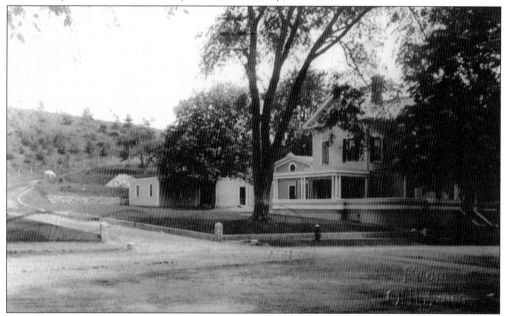

This home at 2 East Street, now the Ipswich Bed-and-Breakfast, was built by clothing store owner Robert Jordan in 1863. Note the wraparound porch and the very small trees on Town Hill in the background. After Jordan's death, it was the home and office of Ipswich family doctor George G. Bailey. (Courtesy of Bill George.)

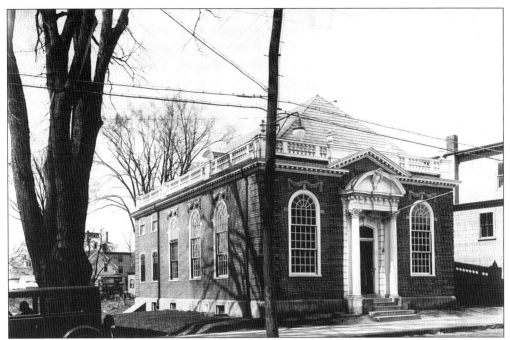

This building, now TD Bank North on Market Street, was built in 1912 and first occupied by the First National Bank of Ipswich. When it built a new building just up Market Street in 1952, the Ipswich Savings Bank moved there from a Victorian building at the corner of Elm and South Main Streets.

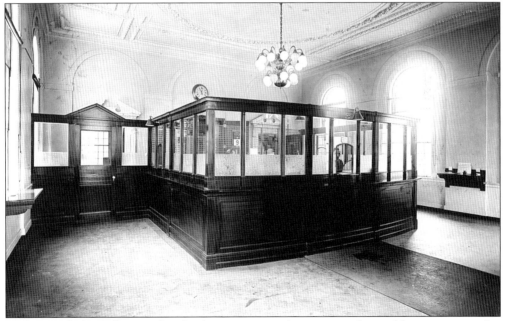

In the era of John Dillinger, when banks were expected to present a fortresslike appearance, this is the interior of the First National Bank of Ipswich, later the Ipswich Savings Bank, and now TD Bank North. Although it looks familiar, the fancy molded ceiling and window tops are now hidden by a drop ceiling.

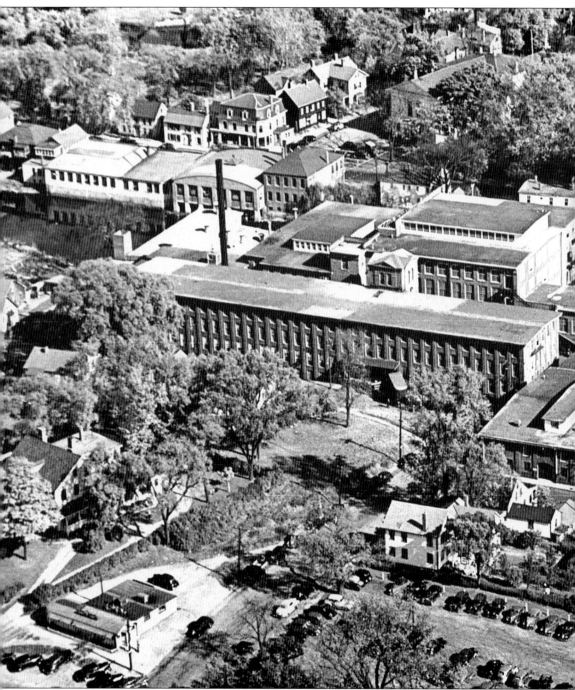

This panorama of the Ipswich Mills was taken just before World War II and shows the complex at its greatest size. After the Ipswich Hosiery Mills closed in 1928, the property was a white elephant until it was finally purchased by Ernest Currier in 1932 with the high bid of $13,000 for all six buildings. At the time of this picture, the long building on the left along Union Street was used by the Martin and Tickelis Women's Shoe Company, which was forced to move to Newburyport when Sylvania and the U.S. government needed more space to make the super

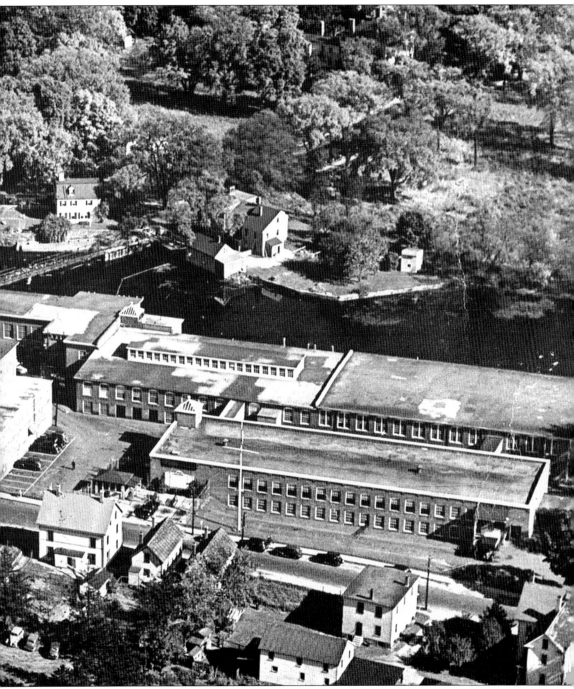

secret proximity fuses for bombs that were such an important weapon in defeating Germany. The large building on the left with the clerestory roof was torn down in 1973. Note the Agawam Diner in the lower left corner. The small building in the center, also torn down, can be seen in the background of the picture on page 119. The remaining buildings are now very successfully occupied by ESBCO Publishing. (Courtesy of the Ipswich Public Library.)

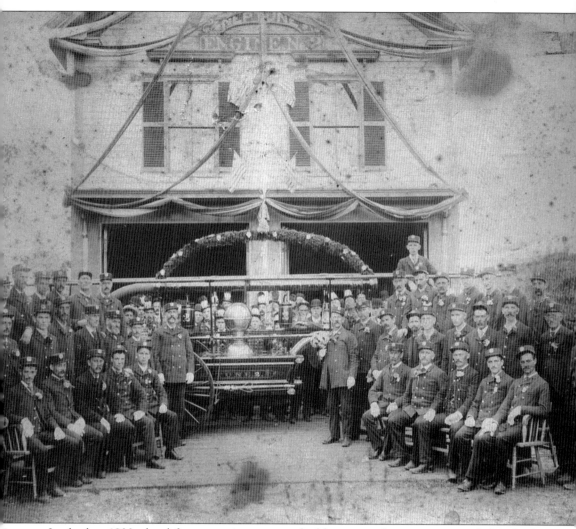

In the late 1800s, local fire protection was supplied by private fire companies with hand tubs such as the *Neptune* shown here. Using manpower to pull the pumpers to the fires, they used muscle power to pump water from private wells, a few random reservoirs, and the Ipswich River. This is the *Neptune* engine in front of their building at Lord's Square. Founded in 1889 with 55 men, they used this equipment until their first gasoline fire truck was purchased in 1912. This building, still standing next to Dunkin' Donuts in Lords' Square, is currently used as an antiques shop. (Courtesy of Jeanne and Jim Engel.)

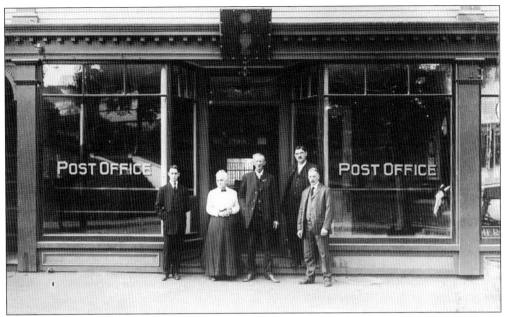

Standing in front of the post office around 1906, when it was housed in the Central Street location that is now Theo's Pizza, are, from left to right, postmaster Parker Hills and his assistants, Elizabeth and Luther Wait, John Russell, and William A. Howe. The post office was there until it moved to its current location in 1939. (Courtesy of the Ipswich Public Library.)

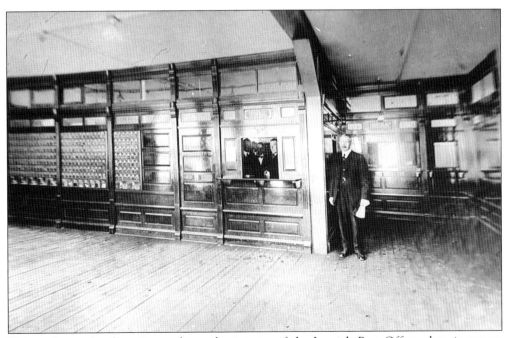

This no-longer-familiar picture shows the interior of the Ipswich Post Office when it was on Central Street and Luther Wait was postmaster. That building, still standing, was called the Amazeen Building.

The John Waite house, built in 1810, that formerly occupied a site at the south end of the South Village Green had been left to Daniel Fuller Appleton. When space was needed to enlarge the Appleton cemetery lot, the house was purchased from the Appleton estate in 1948 for $500 by Raymond Sullivan and moved several hundred yards down County Road and became the Sullivan family residence at what is now the corner of Lane's End. (Courtesy of the Sullivan family.)

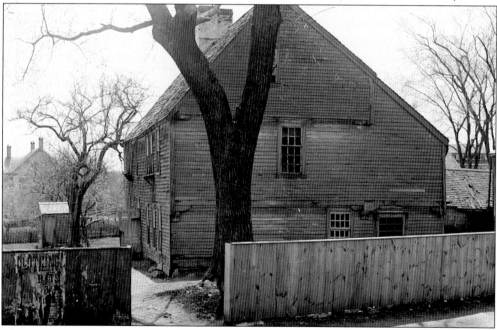

This is a very early picture of the 1677 Whipple House, taken about the time it was acquired by the Ipswich Historical Society in 1898. Of special interest is the roof on the right, apparently covering something in great decay and not seen in other photographs. The privy on the left appears to be the best-preserved part of the property.

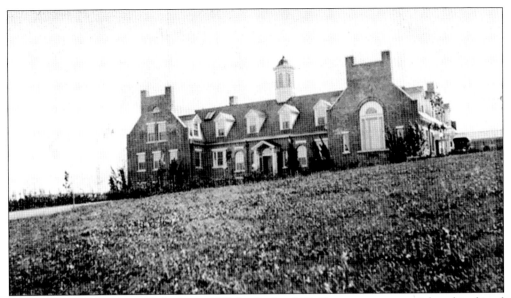

This is the Cable Hospital, built in 1917 by Richard T. Crane as a memorial to his friend Benjamin Stickney Cable, who was accidentally killed at the intersection of Linebrook Road and the Newburyport Turnpike in a car driven by Crane. The hospital closed in 1979 and is now a housing complex called Cable Gardens.

One building of notice is this small building sitting in the rose garden on the front lawn of the Whipple House. Taken from the back ell of the Bradstreet farm in Rowley, it was moved to Ipswich on April 25, 1968. Containing a fireplace and an 18th-century frame, this cordwainer shop was used as a garden library for Isadore Smith (also known as Ann Leighton), who was the originator of the classic Whipple House 17th-century "Housewife's Garden."

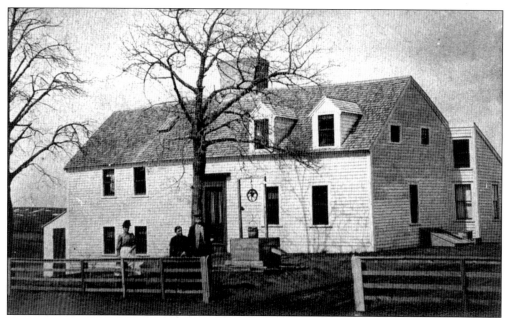

Here is the 1640 Hart House when it was occupied by Civil War veteran Washington Pickard and before it was purchased by Ralph Burnham in 1902. Before his purchase, Burnham was the live-in curator of the Whipple House. After his purchase, the Burnhams moved to the Hart House, and Pickard became curator of the Whipple House.

This is a picture of the Hart House prior to many historic embellishments by Burnham, who was an antiques dealer. As local old buildings were being torn down, he sold many architectural components and furnishings out of town or integrated them into his Ipswich properties. The barn on the right was torn down to allow for the construction of Kimball Avenue, and the barn with the cupola in the background was later moved in 1995 and married to the Hart House as a dining room and function hall.

This view from a 1908 postcard shows a Hart House addition, now the bar, being constructed. Burnham was always one for flamboyant promotions. The men on the roof appear to be dressed in uniforms of the Washington Blues, a local militia organization founded in 1837 that was revived at that time for ceremonial reenactments. (Courtesy of Bill George.)

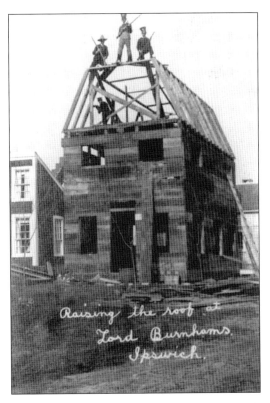

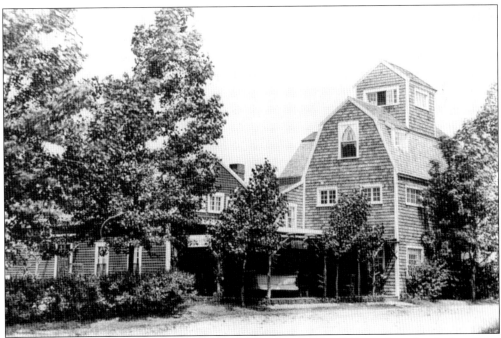

This postcard from the 1930s shows the Hart House after its 1938 purchase by Arthur Edes, program manager of Boston radio station WEEI. The small building on the right was his bar called the Second Landing. (Courtesy of Bill George.)

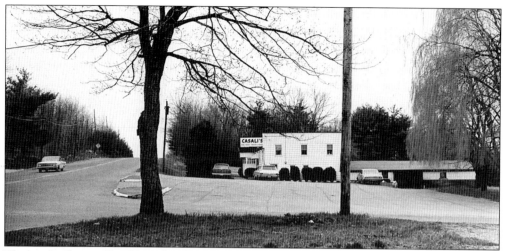

This is the former Casali's, a family-style Italian restaurant on Route 1, at the intersection of Linebrook Road. It was first opened in 1925 by Albert Casali, who had been the spaghetti cook at the Strand Diner downtown. In 1974, it was doubled in size to its present appearance. Later it was operated as the Banyon Club, then as Fantasy's (a gay nightclub), and it is currently the home of Wolf Hill Nursery and Gift Shop.

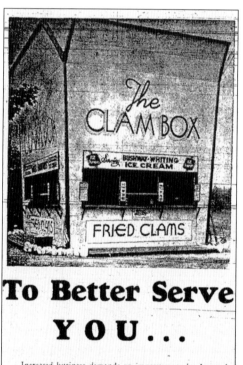

Started by Dick Greenleaf in 1935, the Clam Box has been an Ipswich landmark for 70 years. Apparently they never published a postcard of it, and none of the local collectors have an early photograph. This picture is from a 1938 newspaper advertisement to alert the public that they also served 12 flavors of ice cream and lobster rolls for 20¢.

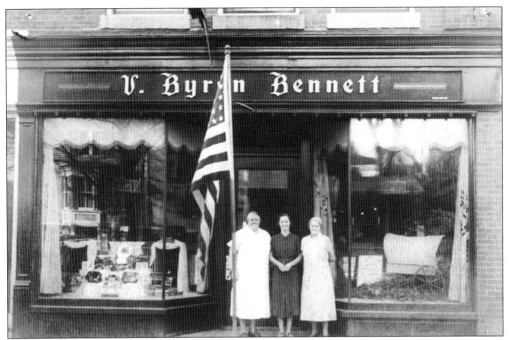

In 1938, Bennett's restaurant occupied a storefront in the Tyler Block, now occupied by Marty's Doughnut Land. Shown here are its pastry cooks, Ethel Bailey (who was Cathy McGinley's grandmother), Janice Robertson, and Mrs. Oscar Davis. By the 1950s, it was purchased by Janice Robertson and was known as Janice's, a popular downtown eatery and high school hangout.

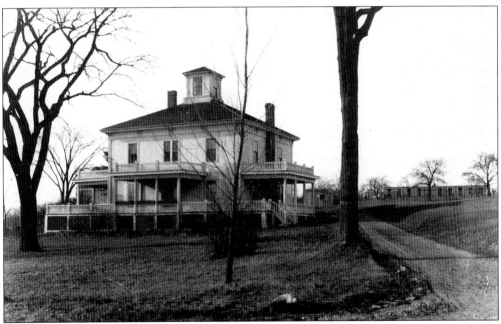

This building should be easily recognizable as home of the Marini family at the top of Marini's Hill on Linebrook Road. The house was built by the William Garrette family after their home on what was then called Scott's Hill burned on August 28, 1880.

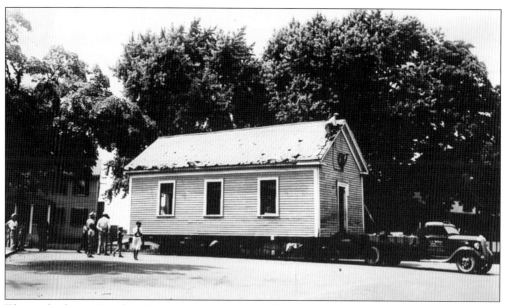

This is the former Linebrook School, purchased for $130 by Charlie Henley, as it is being moved through Lord's Square to become a garage on his Central Street property. He previously owned a shack at Crane Beach where he sold refreshments. But when the town took control of the beach in 1934 and banned all squatters, Henley tried to override its authority by selling from the stern of a boat that he backed onto the beach. (Courtesy of Donna Bowen.)

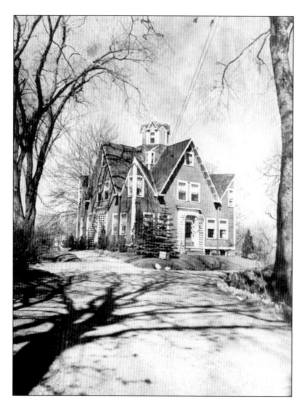

This unique Gothic Revival house at the South Village Green was designed and built by mathematician David Baker in 1846 as an investment property. Constructed as a gentile boardinghouse for lawyers attending the local courts, it was built with money borrowed from the Heards. When Baker could not repay the loan, they took possession and kept it until the early 1920s. At that time, it was purchased by Nellie Huckins, and it became the Gables Tea Room.

Six

PARADES AND
CELEBRATIONS

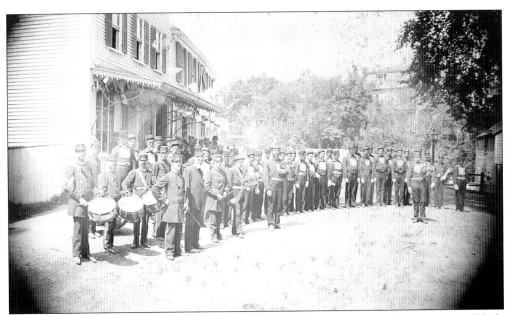

If the date of 1865 written on this original photograph is correct, these are most likely returning Civil War veterans photographed in front of Newman's Block at the south end of the Choate Bridge.

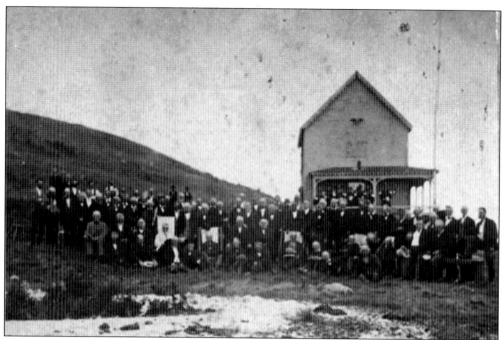

This group of 67 Ipswich men, all over 70, gathered in 1875 at the Little Neck cottage of Col. Nathaniel Shatswell as the guests of Gen. William Sutton. Sutton, an Ipswich native, was the donor of Ipswich's first professional ladder fire truck. His gift of firefighting equipment was then known as "the General Sutton." That name continues on with Ipswich's current ladder fire truck.

Although it cannot be confirmed, this photograph appears to show a reunion of the Washington Blues, an Ipswich militia company founded in 1837. It is known that they had reunions on Plum Island during the 1870s and 1880s, and reports of those reunions tell much of the Ipswich social history of the years prior to the Civil War. In a day with shorter life expectancy when most people did not attend high school, these military reunions were the equivalent of today's high school reunions.

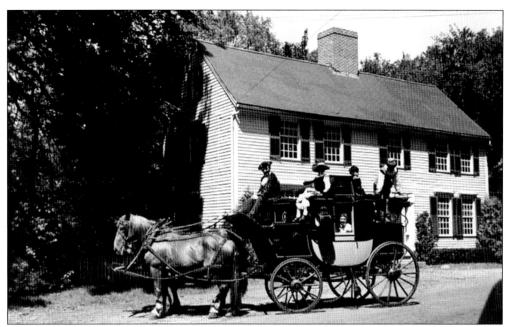

For many years in the 1950s, Ipswich's gala event to attract tourists was called Seventeenth Century Days, sponsored by the Ipswich Historical Society. Many residents participated in colonial costumes with open houses at many First Period homes. There was colonial music and demonstrations of colonial crafts. Although there was some mixing of centuries, here is the historical society's 1890s park drag coach at the South Village Green in front of the Baker House.

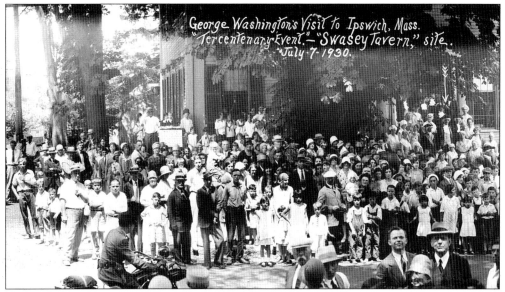

Shown here in front of the former Swasey Tavern at the South Village Green is the reenactment of George Washington's 1789 visit to Ipswich, which was part of the town's 1930 tercentennial celebration. Somewhere there might be a movie of this event as the news report says it was recorded by Pathe News. Follow the arrow under the word "site" and see Forrester Clark playing the part of George Washington.

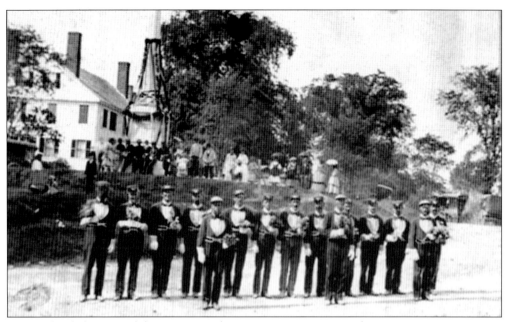

This is the dedication of the town's Civil War Monument on March 13, 1871; a service is still held each Memorial Day at the same place on Town Hill. For the 1871 dedication service, local veterans were supplemented by a military contingent from the Portsmouth Naval Shipyard in New Hampshire.

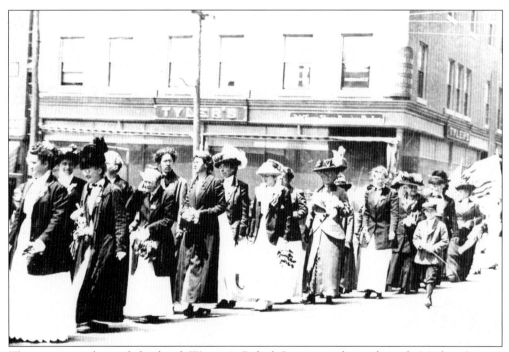

These are members of the local Women's Relief Corps marching through Market Square, probably in 1916. The Women's Relief Corps was a national organization formed to care for the needy veterans of the Civil War and their families.

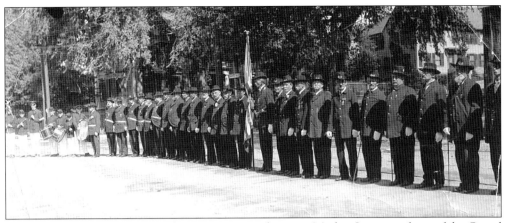

This group of distinguished Civil War veterans is shown in Market Square in front of the Grand Army of the Republic hall in the Caldwell Building. The last surviving Ipswich Civil War veteran was Col. Charles Bradstreet, who died in December 1938.

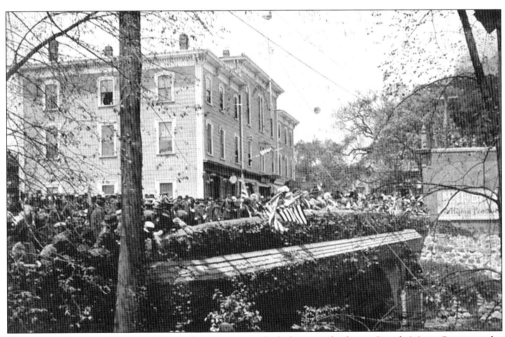

For years, the local Memorial Day observance included a parade down South Main Street and a stop on the Choate Bridge for remembrances of those lost at sea. This picture, taken in the 1920s, could easily be duplicated today, but because of traffic concerns, this part of the observance has been transferred to the County Street Bridge.

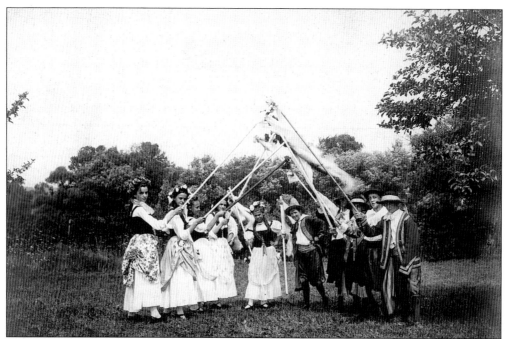

This scene from the 1910 Ipswich Historical Society's 20th anniversary pageant seemed out of keeping with Puritan Ipswich until the souvenir program revealed that it represented English 17th-century levity. Such behavior was unacceptable to the Puritans and acted as a catalyst for them to immigrate to New England and create their own society.

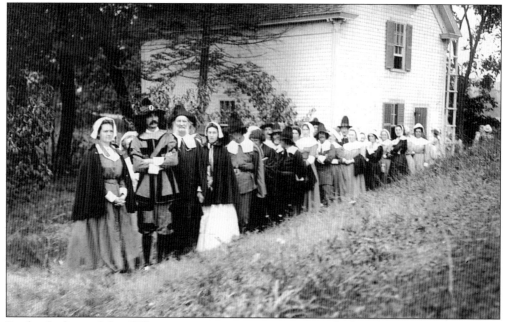

By the final act of the 1910 anniversary pageant, participants had worked very hard to create and dress in costumes that properly reflected their Puritan ancestors. This event was held at the Peabody estate on County Road, now the Ipswich Hellenic Center.

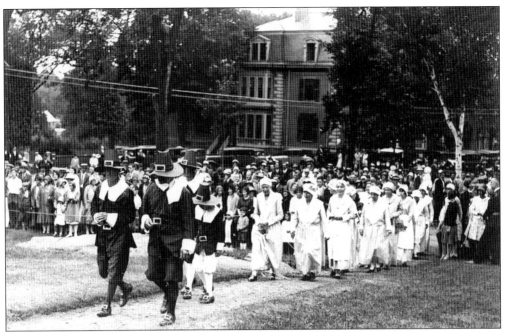

Here the dignitaries and representatives of the town's "first families" can be seen entering the First Church for a ceremony during the tercentennial celebration in 1930. Although the event should have been held in 1933, 1930 was the 300th anniversary of the settlement of Boston, and the state told Ipswich it would lose out on national publicity if they did not go along.

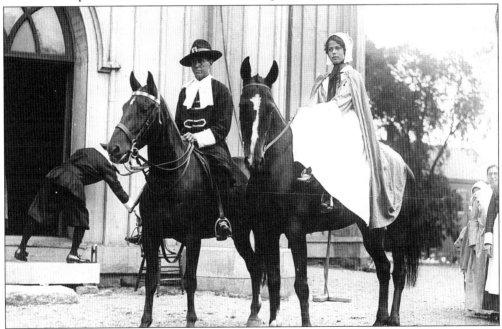

These people were costumed participants of the 1930 tercentenary celebration. The most lasting benefit of the event was that it was the first time that Ipswich's historic houses were identified by individual name plaques. Homeowners were asked to supply the town clerk with documentation for all houses built before 1775.

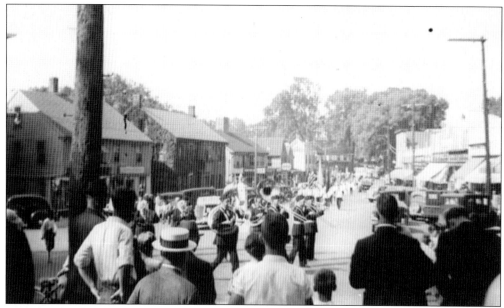

This shows a 1937 Fourth of July parade on Market Street. At the depth of the Depression, the people of Ipswich needed a homegrown parade to raise their spirits.

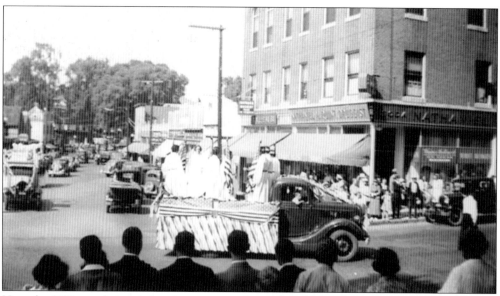

Here the 1937 parade is turning the corner in front of the Tyler Block from Market Street onto Central Street. Just that March, Tyler's Department Store had been divided, with Nathaniel Quint leasing the Central Street corner for a drugstore. Quint had previously operated a drugstore in Essex.

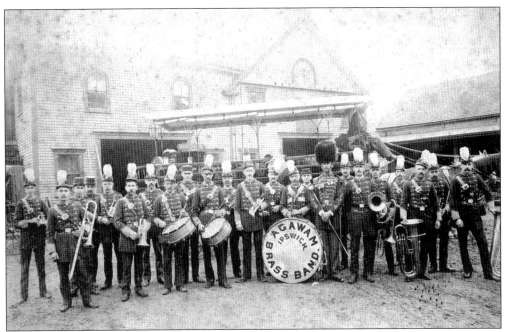

In this photograph from the 1890s, the Ipswich Brass Band is lined up in front of William Brown's Agawam Livery Stable in back of the Agawam Hotel on Town Hill. The wagon is probably the barge *Centennial*, which gave the band a prominent presence during out-of-town summer engagements. They also supported out-of-town stock companies at the Ipswich Opera House. (Courtesy of the Barton Collection, IHS.)

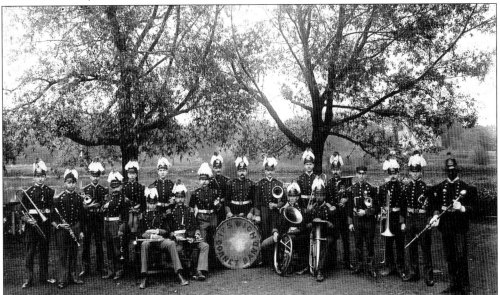

This is the Ipswich Cornet Band, taken near its band house on Estes Street. At the beginning of the 20th century, there was enough demand for several local bands, who alternated on the Town Hill bandstand on Wednesday and Friday nights. The Ipswich Cornet Band played on river cruises, had many out-of-town engagements (especially at local summer resorts), and even marched in funeral processions, playing dirges over open graves. (Courtesy of the Barton Collection, IHS.)

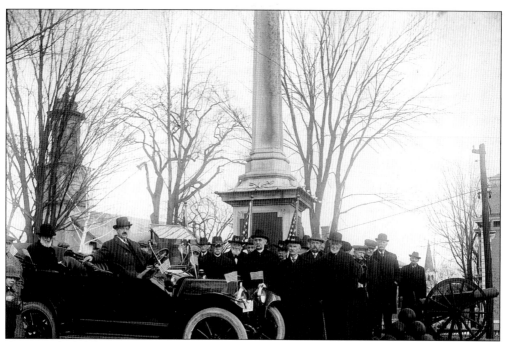

George Schofield was a dynamo in Ipswich history. In addition to being the owner and editor of the *Ipswich Chronicle*, he was a state senator. He is seen here surrounded by Civil War veterans in front of the Civil War Monument with a new Buick given to him by the veterans for sponsoring the legislation that gave them a long-deferred Civil War pension.

What appears to be part of an Ipswich parade is in fact a show of force. During the violence of the 1913 mill strike when a Greek woman, Nikoleta Pantelopolou, was killed, Ipswich had to call for police assistance from surrounding cities and towns to restore order.

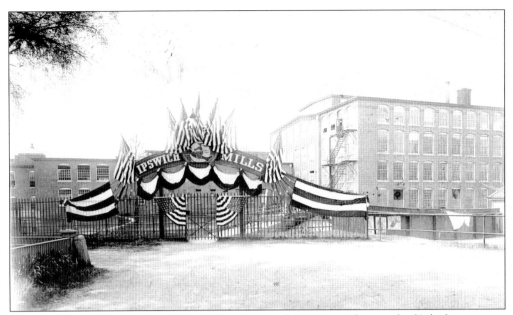

After the United States entered World War I in April 1917, Ipswich was a hotbed of patriotism. With victory gardens, bond drives, women's organizations making bandages, and men leaving for training camps, Ipswich had gone to war. The Ipswich Hosiery Mill celebrated its prosperity resulting from war contracts by giving its 3,100 employees, 1,400 of whom worked in Ipswich, a 30 percent raise and erected this patriotic display at its South Main Street gate to the footbridge across the Ipswich River dam.

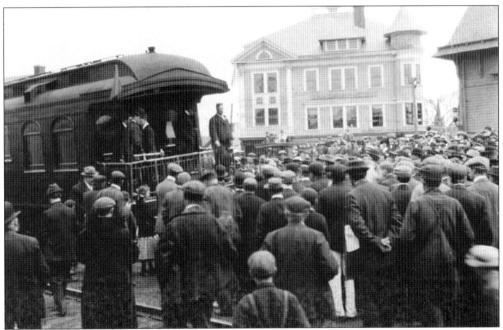

There was no larger a political celebration in Ipswich than the "whistle stop" at the Ipswich Railroad Station during Teddy Roosevelt's 1912 "Bull Moose" campaign. The second of three Damon Buildings, all of which burned, is in the background.

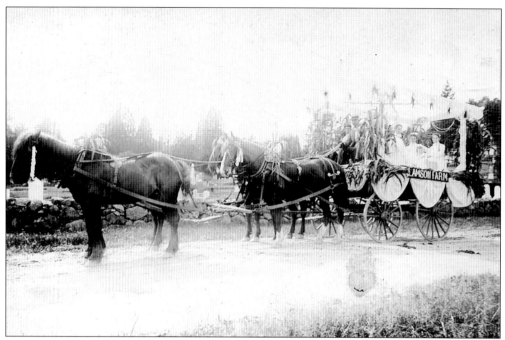

Although the what, where, and when of this picture has not been identified, it is part of the Ipswich Historical Society's collection and typical of the floats in the town's many parades.

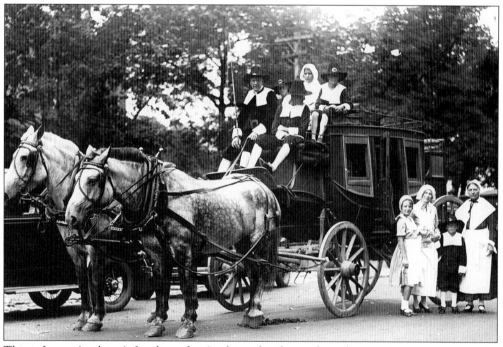

This is James Appleton's family in the Appleton family coach in the 1930 tercentenary parade. Since his barn on Mill Road had burned in a $25,000 fire in October 1929, it is quite possible that his coach was saved from that fire.

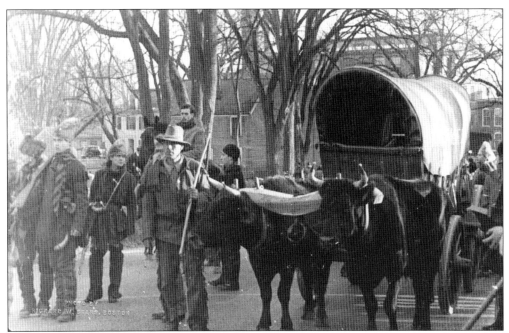

In 1937, Ipswich residents participated in a reenactment of the historic 1787 journey of the first covered wagons to leave for Marietta, Ohio. The ox-drawn caravan set out from in front of the Ipswich Post Office on Central Street. The caption on the side of wagon read, "For the Ohio!"

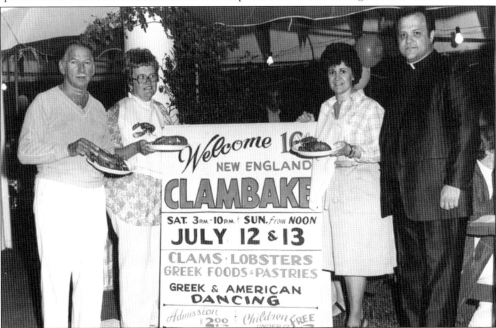

For many years, the annual picnic at the Greek Hellenic Center on County Road has been a "five-star" event. With its Greek food and dancing, it has always been a well-attended north-of-Boston event. Pictured here in the 1980s are church members, including, from left to right, church president Chris Nahatis, Betty George, Kay Brown Bukgaris, and the local Greek pastor Fr. John Govostes.

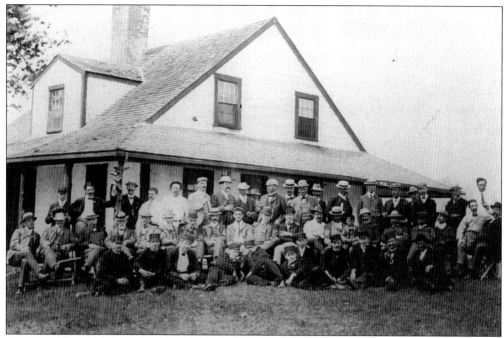

Here is a group celebrating at the Willow Cottage on Plum Island's Ipswich Bluff, a favorite summer destination served by the steamboat *Carlotta*. (Courtesy of Bill George.)

In July 1920, members of the First Church celebrated a visit of the Congregational minister from Ipswich, England. This group is reported to have included Appletons, Tuckermans, and Henry Cabot Lodge. After having their picture taken in back of the church, they visited Appleton Farms and Castle Hill and had lunch at Russell's Restaurant in Depot Square.

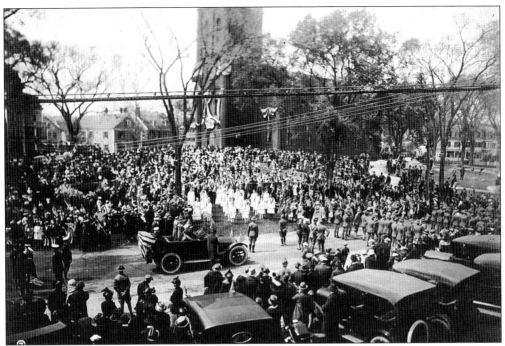

This scene shows the formation of the great 1919 Armistice Day parade in front of the Ipswich Public Library on Town Hill. The First Church, built in 1848 and burned in 1946, is in the background.

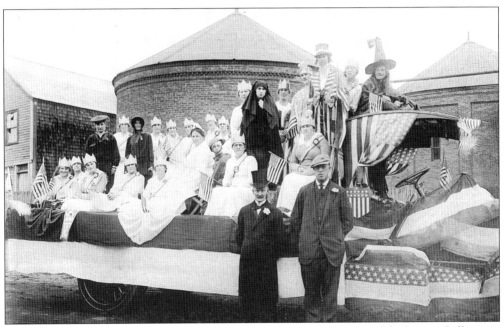

According to the caption with this original photograph, received as part of the Barton Collection, this float was part of a 1920s parade. Taken in front of the gas company buildings on Hammatt Street, the man in the top hat is David Johnson, foreman of the finishing room at the Ipswich Hosiery Mill, and the tall driver is Al Waite. The women on the float are mill workers. Note the woman dressed as an Ipswich witch on top of the cab roof.

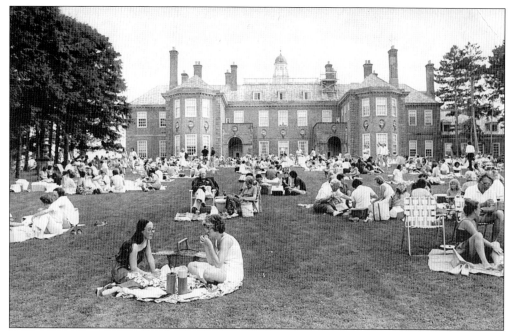

For many years, the former Crane Estate at Castle Hill has been the preferred location for grand wedding receptions, Christmas events, weekly picnics with live music, and gala Fourth of July picnics and fireworks on the Grand Allee, to say nothing of family outings at Crane Beach. This photograph was taken around 1980.

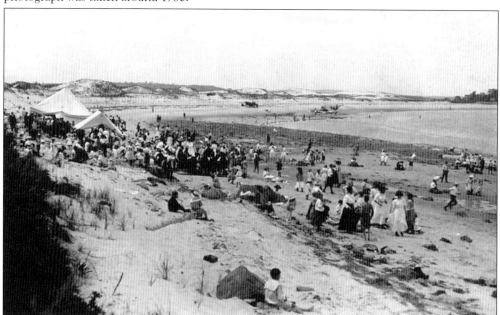

Since 1911, the Crane Beach picnics have been a major celebration for the school children of Ipswich. The first picnic was an event to celebrate Cornelius Crane's birthday and introduce him to the children of the town where his father had just built a grand summer estate. There were very few bathing suits at these first Crane picnics. It was very much a dress-up event for everyone.

Seven

AN APPLETON ALBUM

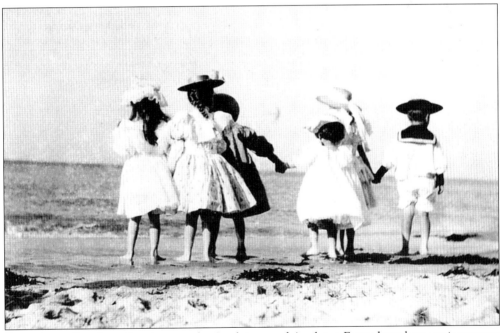

Since the earliest days of settlement, the Appletons and Appleton Farms have been an important part of Ipswich history. While they were a wealthy family who traveled in the highest ranks of society, they also were farmers and took leading roles in all the nation's wars through World War I. It has often been said that the very rich are just like everyone else except they have much more money. In the following photographs, the family at the beach, entertaining presidents and royalty, riding to the hounds, and enjoying the finest of transportation are seen. Fortunately, it easily bring their lives into focus because their ancestral home, Appleton Farms, is now a local property of the Trustees of Reservations, preserved in perpetuity, and open to the public for all to enjoy. (Courtesy of David Thayer.)

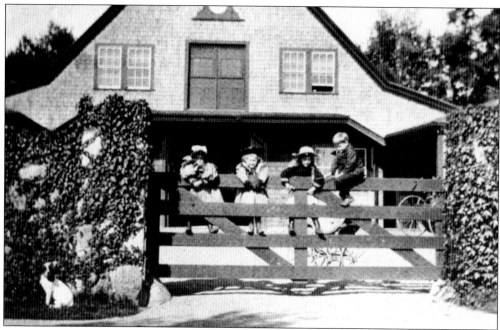

This 1896 photograph shows Appleton and Tuckerman children hanging on the gate in front of the New House stable. Although many of the farm buildings at Appleton Farms have recently been restored by the Trustees of Reservations, this building had been neglected too long to be saved and was torn down. (Courtesy of David Thayer.)

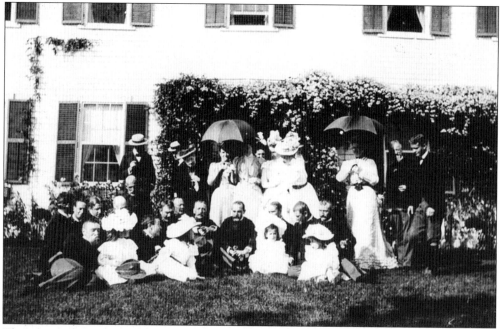

This photograph of a grand gathering was taken after breakfast on September 14, 1898, at the Budd Appleton estate, Waldingfield, then part of Appleton Farms. Included with the extended family and visiting military officers is Isabella Stewart "Mrs. Jack" Gardner, said to be standing in the middle of the back row. (Courtesy of David Thayer.)

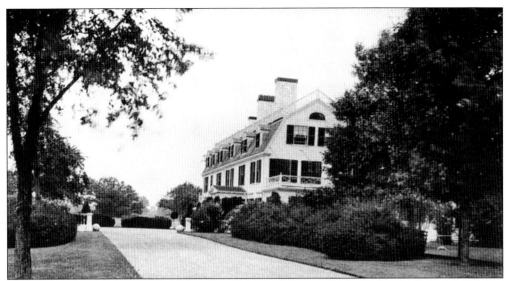

The Appletons provided a simple solution when it came to naming their new summer mansion. When this house was completed in 1891 and officially named New House, Francis Appleton's father's home became Old House. (Courtesy of David Thayer.)

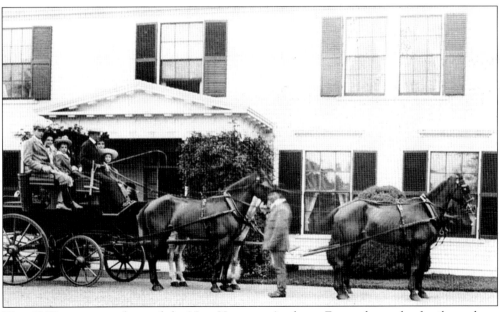

This 1907 turnout in front of the New House at Appleton Farms shows the family ready to depart for the Baldpate Inn at Georgetown. (Courtesy of David Thayer.)

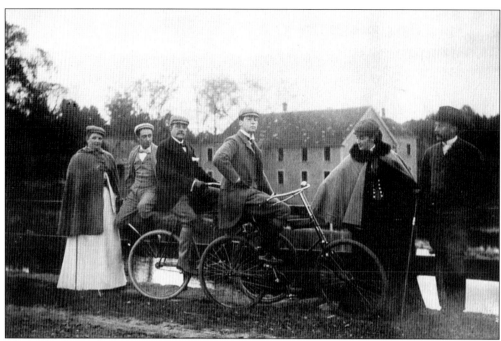

This 1895 view taken from Norwood's Bridge on Mill Road shows several Appletons and their guests, with the Isinglass Mill in the background. (Courtesy of David Thayer.)

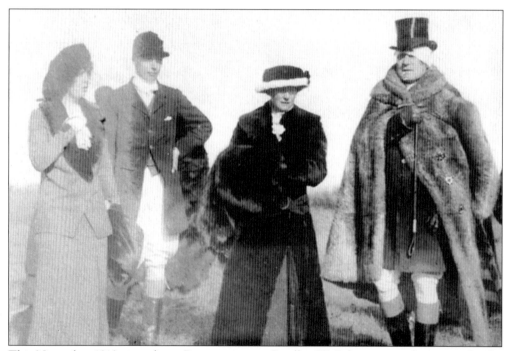

This November 1913 view shows Boston attorney Bradley W. Palmer, somewhat worse for the wear, after being thrown during a Myopia Hunt Club race on his private course. (Courtesy of David Thayer.)

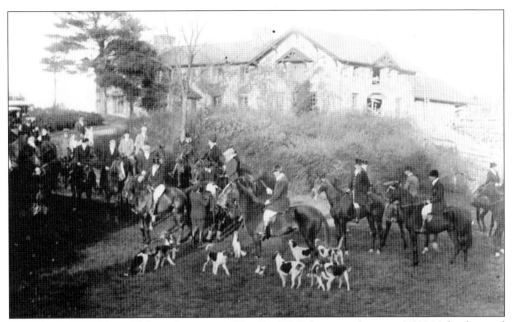

Here the Myopia Hunt Club at the estate of Bradley W. Palmer can be seen. In 1944, he donated to the state almost 2,000 acres between Linebrook and Topsfield Roads for the wildlife sanctuary and state forest called Willowdale, named after his estate. (Courtesy of David Thayer.)

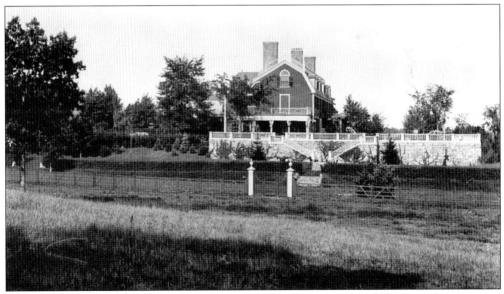

This 1902 view shows the elaborate landscaping at New House, built in 1890. It was last occupied by Fannie Appleton, the wife of its builder, Francis Appleton Sr., who had died in 1929. She died in 1957; the furniture was sold off in 1962, and New House was torn down the following year. (Courtesy of David Thayer.)

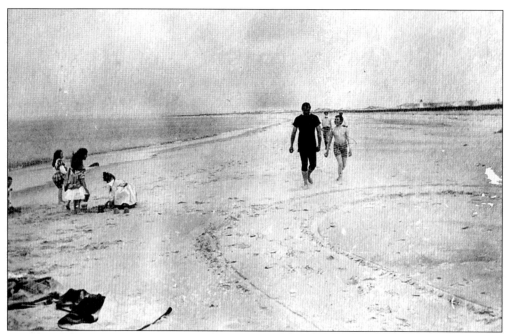

Crane Beach, called Ipswich Beach at the beginning of the 20th century, was almost a private playground for the extended Appleton family. This 1898 picture shows, from left to right, Margaret Smith, Julia, Madeline, their father Budd Appleton, and Cotton Smith. The Ipswich lighthouse can be seen in the dunes on the right. (Courtesy of David Thayer.)

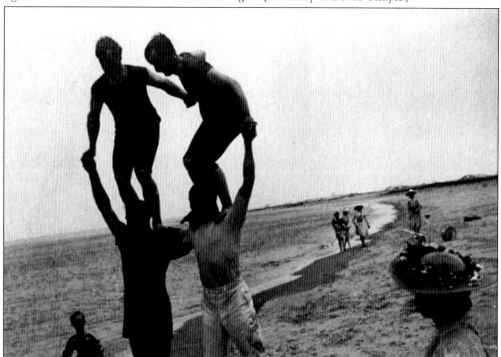

This 1899 view of Ipswich Beach shows Budd and James Appleton and Flitner and Bob Thayer showing off their athletic prowess. (Courtesy of David Thayer.)

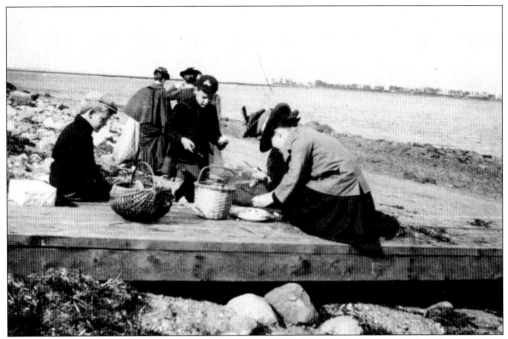

These formally dressed Tuckermans, Appleton family in-laws, are enjoying an October picnic at Great Neck in 1900. Buildings at Ipswich Bluff on Plum Island are in the background. (Courtesy of David Thayer.)

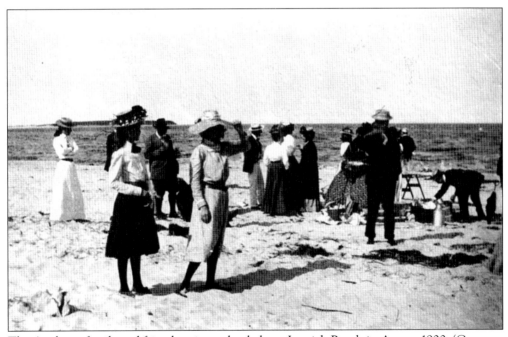

The Appleton family and friends enjoy a clambake at Ipswich Beach in August 1900. (Courtesy of David Thayer.)

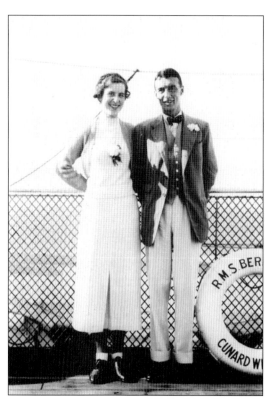

In this 1935 picture are Francis R. Appleton Jr. and his wife, Joan, on their honeymoon voyage aboard the liner *Berengaria*. According to the original album caption, they occupied the Imperial Suite, compliments of the Cunard Line. (Courtesy of David Thayer.)

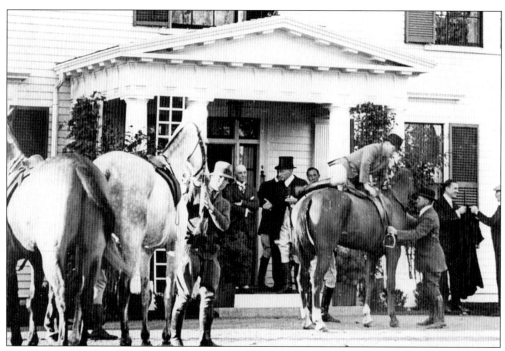

Seen here is His Royal Highness Edward VIII, the Duke of Windsor, mounting his horse, Desert Queen, after lunch at New House on October 23, 1924. (Courtesy of David Thayer.)

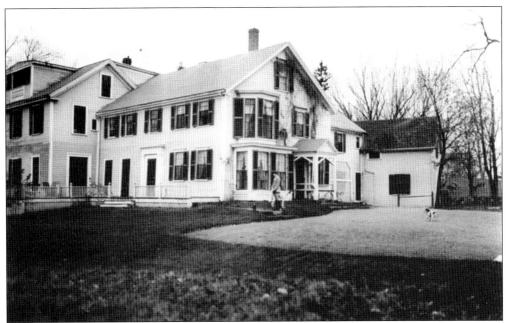

This is Old House, the home of Daniel Fuller Appleton that was last occupied by Col. Francis R. Appleton Jr., who died in 1974, and his wife, Joan, who died in 2006. Although vacant for the last few years and in need of significant renovation, the Trustees of Reservations hope to restore it to complement the recently restored farm buildings that were all part of the working farm first established in 1636. (Courtesy of David Thayer.)

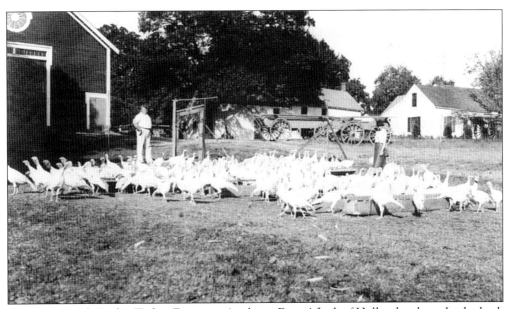

Competing with Poole's Turkey Farm was Appleton Farms' flock of Holland turkeys. In the back is farm superintendent John Skowronek and Joan Englehart Appleton, who, until her recent death, visited the farm almost daily. On the left is the dairy barn that was struck by lighting and burned in August 1943. (Courtesy of David Thayer.)

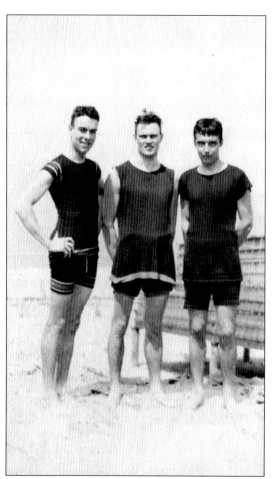

This 1907 photograph shows the future Col. Francis R. Appleton Jr., on the right, and two unidentified friends in that era's male beach attire. (Courtesy of David Thayer.)

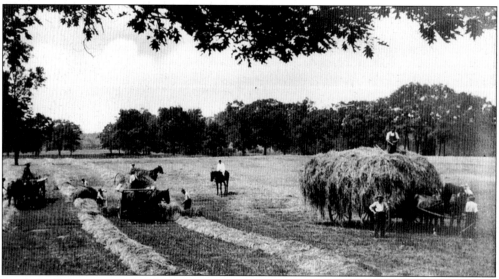

Appleton Farms was, and still is, a major working farm. Seen here is a haying scene in 1912. (Courtesy of David Thayer.)

Still to be seen at the confluence of several trails on the Grass Rides at Appleton Farms is this pinnacle, once an ornament on Harvard University's Gore Hall (the former library). It was installed by Francis R. Appleton Sr. on his 60th birthday on August 5, 1914. (Courtesy of David Thayer.)

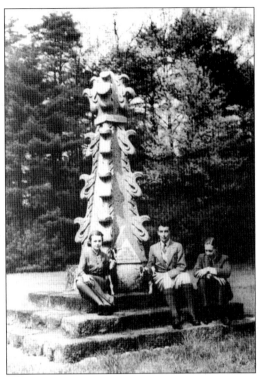

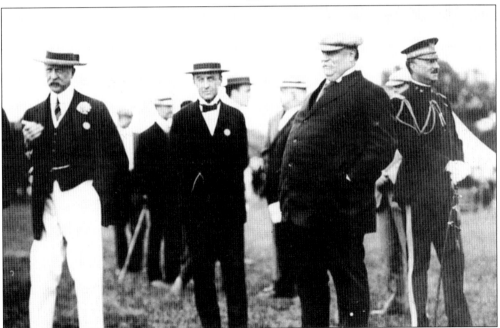

The prominence of the Appleton family is indicated by this photograph showing Francis R. Appleton Sr. being greeted by Pres. William Howard Taft on Labor Day 1911. Arthur L. Devins is seen on the left. That year, the Taft family had rented a summer home in Beverly Farms. In back of the president is his military aide, Col. Archie Butt, who was lost on the RMS *Titanic*. (Courtesy of David Thayer.)

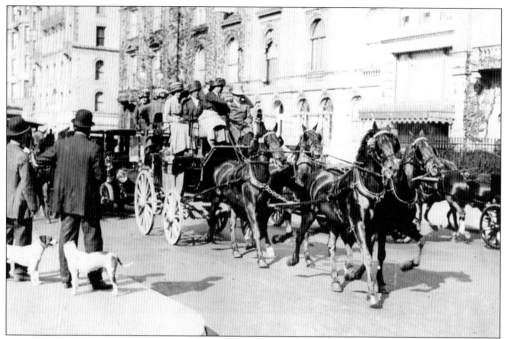

This 1910 photograph from the Appleton family album represents the social set in which they traveled. It shows the Ladies Coaching Club at the corner of 57th Street and Fifth Avenue in New York City, their winter home. (Courtesy of David Thayer.)

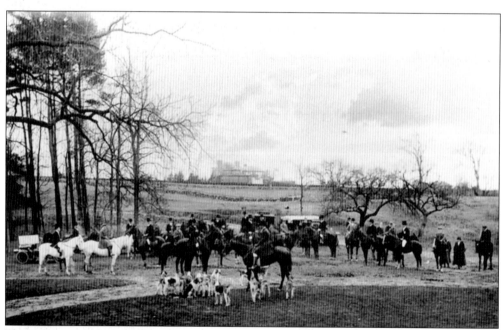

Fox hunting was always an important part of the social life at Appleton Farms. This 1907 Myopia Thanksgiving Day meet was recorded at the kennel of the Appleton family, where they had bred a new line of hunting beagle. (Courtesy of David Thayer.)

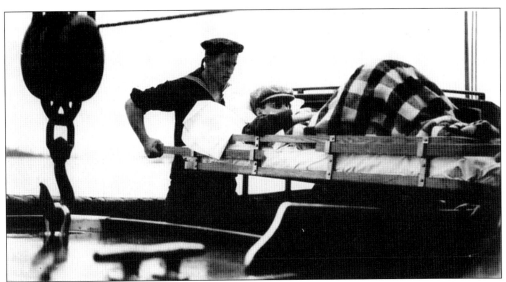

This tragic picture shows James (Jimmy) Appleton Jr. being carried aboard J. P. Morgan's yacht *Corsair* in June 1915. Jimmy died of leukemia in October 1915. Today the cooperative garden program at Appleton Farms is held at what is known as "Jimmy's Barn." (Courtesy of David Thayer.)

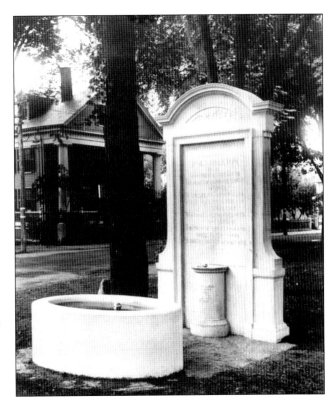

Still a prominent fixture at Ipswich's South Village Green is this monument and horse trough, now used as a planter, given to the Town of Ipswich by the James Appleton family in 1916 in memory of their son Jimmy. (Courtesy of David Thayer.)

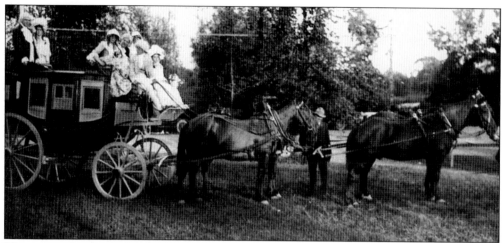

This is an Appleton family coach getting ready to participate in the historical society's 20th anniversary pageant in 1910. Great excitement reigned at the dress rehearsal when the horse pulling a spectator's buggy got spooked, upsetting the buggy, dumping its occupant, and running away. The horse was finally captured behind the South Parish Church by a man dressed as an American Indian. (Courtesy of David Thayer.)

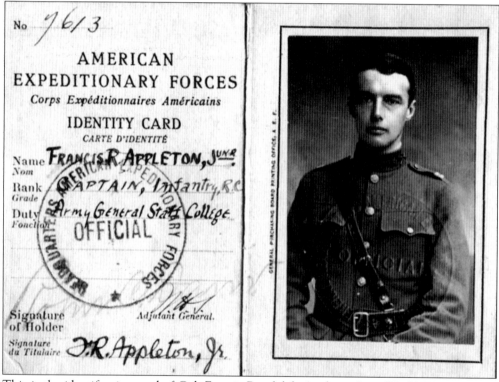

This is the identification card of Col. Francis Randolph Appleton Jr., a World War I veteran and one of the founders of the American Legion. In later years, he was always a prominent participant in Ipswich's Memorial Day observances when he annually recited Logan's address at the Civil War Monument on Town Hill. (Courtesy of David Thayer.)

Eight

NOTABLE NATIVES

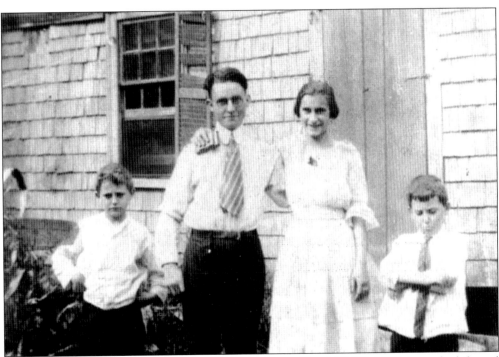

These are the Bowens at their home on Summer Street. Harold (1910–1979) is on the left, and his twin brother, Roland, is on the right. Their brother, Henry, and his wife, Martha, are in the middle. Henry was a railroad conductor. Both Harold and his father, Henry, were responsible for preserving much local history in newspaper columns. Harold's articles are preserved in three different editions of books titled *Tales of Olde Ipswich*. (Courtesy of Donna Bowen.)

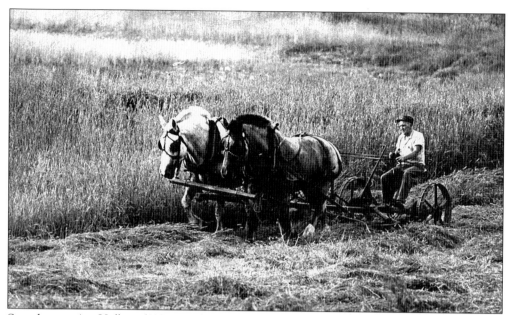

Seen here is Art Hulbert (1922–1981) with his team, Harry and Bess. One of the last Ipswich farmers to work with a team of horses, Hulbert is one of the reasons that Ipswich retains so much open space. In addition to his farm work, with his wife, Mildred "Mim" Hulbert, he also used his team for hayrides and sleigh rides for local events. (Courtesy of Mildred Hulbert.)

Art Hulbert and his team were also featured in the public television special *The Adams Chronicles*. With fancy work harnesses given to him by Joan Appleton, he won a front-page story in the *New York Times*. (Courtesy of Mildred Hulbert.)

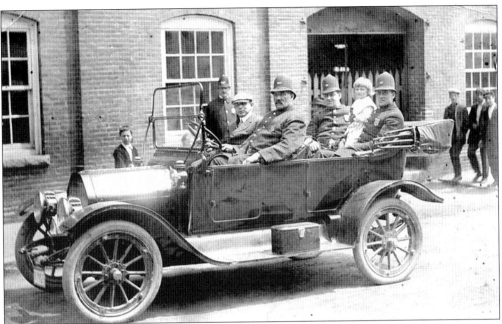

When most people look at this picture, the initial reaction is "Keystone Cops," but further research indicates that the building was part of the Ipswich Hosiery Mill, since torn down. The car no doubt belongs to local Buick dealer Ernest Currier, and the policeman in the front seat is Ipswich officer Bill Lord, described as "a mountain of a man." (Courtesy of the Ipswich Public Library.)

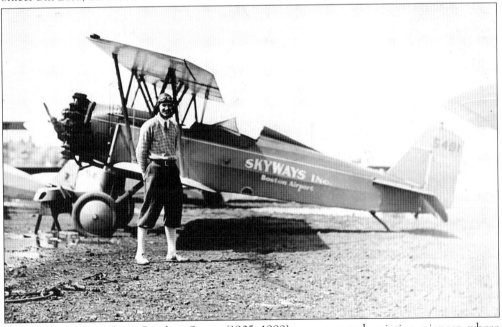

Topsfield Road resident Crocker Snow (1905–1999) was a noted aviation pioneer whose international sport-flying license was signed by Orville Wright. The many facets of his life may be read in his fascinating autobiography, *Log Book: A Pilot's Life*. The Federal Aviation Administration called his local grass landing field Ipswich International Airport. (Courtesy of Crocker Snow Jr.)

This is Agnes Robishaw (1917–2001), known to all as "Iggie," one of Ipswich's best-known residents. Her working life was mostly spent as a switchboard operator at Sylvania, but after retirement, she became a cashier at the Agawam Diner. She was known for her Greek dancing and for being a Democratic political supporter who was always in demand. She was best known as the writer of the *Ipswich Chronicle*'s gossip column "Iggie's Items," as well as for her flamboyant clothes and colorful personality.

To anyone familiar with the stern visage in the portrait of Daniel Fuller Appleton (1826–1904) that hangs just inside the door at the Heard House, headquarters of the Ipswich Historical Society, it is nice to see that he was once young and quite handsome. This patriarch of the local family was a lawyer and controlling member of the Waltham Watch Company and is credited with reacquiring major portions of Appleton Farms that had previously been sold out of the family. (Courtesy of David Thayer.)

Augustine Heard (1785–1868) was one of the most successful Americans in the China Trade. As a partner in Russell and Company, later as the owner of Augustine Heard and Company, he did business in Canton, Hong Kong, and Shanghai, introducing steamship technology to the region. When he retired to his hometown of Ipswich, he was a generous philanthropist, giving the town its first public library.

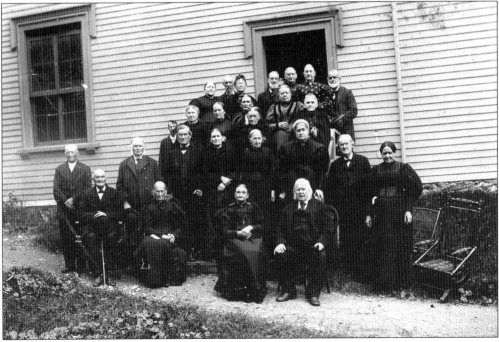

These senior citizens are being honored by the Methodist Church. Each of these members of the congregation is more than 75 years old. Lighthouse keeper Benjamin Ellsworth is standing second from the left. This doorway is opposite the children's entrance to the Ipswich Public Library.

188 Essex St., TAYLOR & PRESTON, Salem, Mass.
1886

Nathaniel Shatswell is certainly the story of a local boy who made good. A former farmer who formed his own company at the start of the Civil War, Shatswell rose to the rank of colonel through his actions dealing with the defense of the nation's capitol. Later he was assistant superintendent of the Ipswich House of Correction, and in 1890, he went to Washington, D.C., as the curator of the museum at the Department of Agriculture. (Courtesy of the Town of Ipswich.)

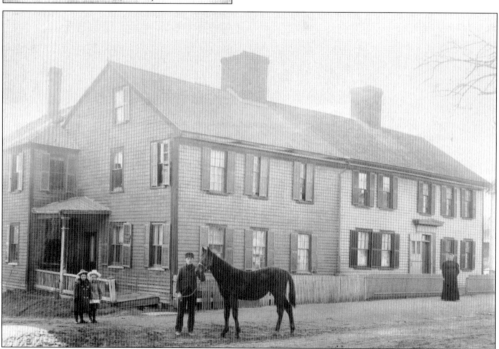

Built around 1685, this is the home of the extended Shatswell family just north of Lord's Square on High Street. When he was not fighting the Civil War or working in Washington, this was the home of Col. Nathaniel Shatswell. (Courtesy of the Town of Ipswich.)

This is Adeline (Mrs. Thomas Franklin) Waters, wife of the local minister and historian, with her children, George and Miriam, in front of their parsonage opposite the South Village Green. During the 1930s, this house became the Scahill Funeral Parlor.

Joseph Claxton (1821–1909) was a typical Ipswich resident at the beginning of the 20th century. Prior to the beach site becoming Woodbury's Hotel, he had worked there for Humphrey Lakeman at his Castle Neck farm. In later life, Claxton was a pillar of the Methodist Church.

This is a self-portrait of noted artist Carl Nordstrom (1876–1965), who lived at Nabby's Point. Originally a well-known portrait photographer, he studied at the School of the Museum of Fine Arts in Boston and gradually shifted his focus to oil painting. He was also the operator of a Gloucester summer art school. As time passes, there is greater appreciation for his work and contributions to the history of local art. (Courtesy Eva Nelson.)

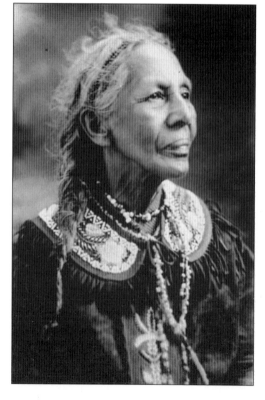

This is Ipswich's claim to Native American royalty in the form of Emma Jane Mitchell Safford, a direct descendant of the Wampanoag chief Massasoit. She had come to town as a somewhat outcast minority, married the son of former black slaves, and became one of the best-loved and respected members of the community.

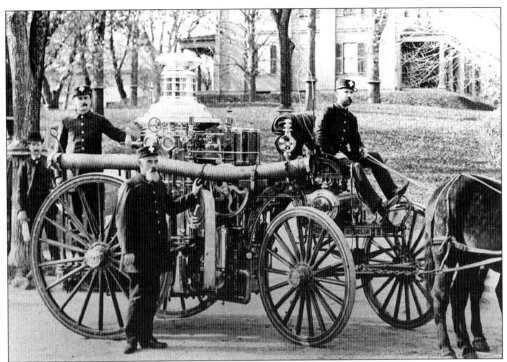

The picture of the Masconomet Steam Fire Engine Company is thought to have been taken in front of the Jeffrey's Neck Road summer home of Gen. William Sutton, which has since been torn down. The town's first professional truck, it was purchased for $3,200 after two devastating fires in 1894 and the installation of a town water system. (Courtesy of the Barton Collection, IHS.)

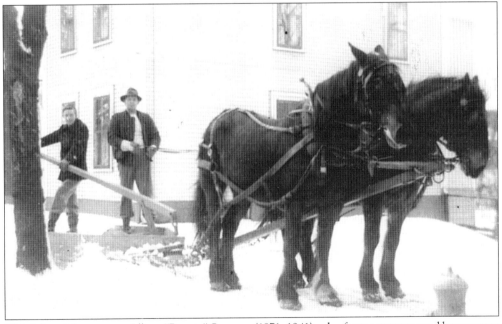

This is Ipswich teamster Albert "Bernie" Spencer (1871–1941), who for many years used horsepower to plow Ipswich sidewalks. For the last 25 years of his life, he was a local railroad crossing tender.

Arthur Wesley Dow (1857–1922) is probably Ipswich's best-known artist. Born and raised here, he studied in France and returned to operate his well-attended Ipswich Summer School. As well as creating his paintings and Japanese inspired prints, he was the director of the Fine Arts Department at Columbia Teachers College in New York City.

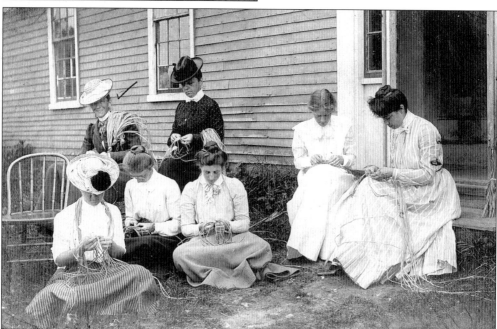

At the beginning of the 20th century, Arthur Wesley Dow purchased and restored the so-called Emerson-Howard house on Turkey Shore Road, where he conducted a popular, well-attended art school. During summers between 1891 and 1907, he and his wife, Minnie, taught many different arts and crafts, some of his students, such as Georgia O'Keeffe, becoming well known. This picture, taken in 1900, shows students learning the art of basket making.

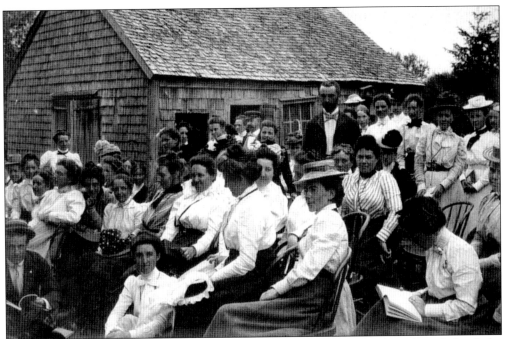

Arthur Wesley Dow is seen here standing among his summer school students behind the Emerson-Howard house on Turkey Shore Road, then called Prospect Street. It would be interesting to know how many students made this rustic barn the subject of an art composition.

This is the interior of Arthur Wesley Dow's Spring Street studio on what he called Bayberry Hill. The stairs led to a balcony that overlooked the marshes and the seacoast. This unoccupied building burned in March 1930. The fire caused $3,000 worth of damage to the building and $6,000 in destroyed paintings, furniture, and a valuable statue of a Chinese god.

Across America, People are Discovering Something Wonderful. Their Heritage.

Arcadia Publishing is the leading local history publisher in the United States. With more than 3,000 titles in print and hundreds of new titles released every year, Arcadia has extensive specialized experience chronicling the history of communities and celebrating America's hidden stories, bringing to life the people, places, and events from the past. To discover the history of other communities across the nation, please visit:

www.arcadiapublishing.com

Customized search tools allow you to find regional history books about the town where you grew up, the cities where your friends and family live, the town where your parents met, or even that retirement spot you've been dreaming about.